IMAGES
of America

BLOOMFIELD

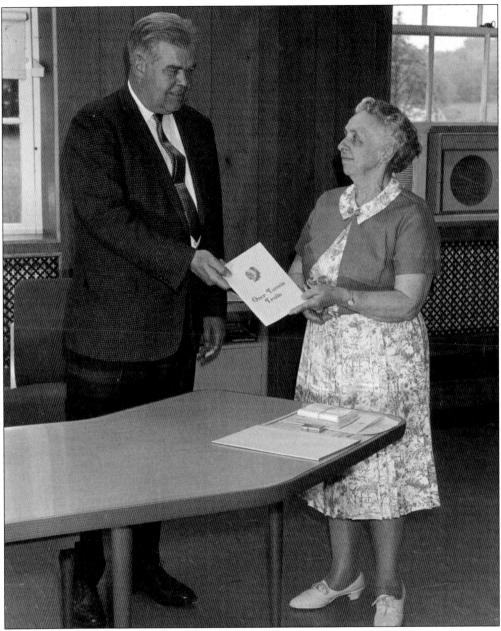

Wintonbury Historical Society was founded in 1951 to "collect and preserve the history . . . disseminate documents . . . etc." Charlotte R. Goodrich, founding member and, for many years, historian, presents a copy of one of the Wintonbury Historical Society's earlier books to Edward R. Rogean, superintendent of schools. The first edition of *Over Tunxis Trails* was written as part of the town's tercentennial celebration.

IMAGES
of America

BLOOMFIELD

Wintonbury Historical Society

ARCADIA
PUBLISHING

Copyright © 2001 by Wintonbury Historical Society
ISBN 978-0-7385-0954-9

Published by Arcadia Publishing
Charleston SC, Chicago IL, Portsmouth NH, San Francisco CA

Printed in the United States of America

Library of Congress Catalog Card Number: 2001093035

For all general information contact Arcadia Publishing at:
Telephone 843-853-2070
Fax 843-853-0044
E-mail sales@arcadiapublishing.com
For customer service and orders:
Toll-Free 1-888-313-2665

Visit us on the Internet at www.arcadiapublishing.com

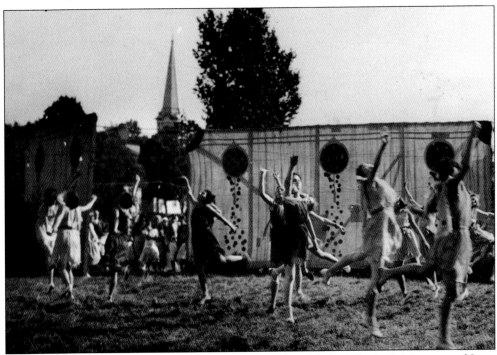

This book was compiled by Roberta Randall Kania, Eileen Phelps, Elizabeth Merrow, and Lucy Woodford Wirsul, all of the Wintonbury Historical Society. In the tercentennial celebration in 1935, almost everyone in town was involved. Shown is a pageant that was presented: "They lift their veils, and behold, we see the Dawning of Creation!" Three of the four authors were in the pageant, Lucy Woodford Wirsul as a page, Roberta Randall Kania as the state of Virginia, and Eileen Phelps as the middle of an embarrassed trio who spelled "Bury-Ton-Win."

CONTENTS

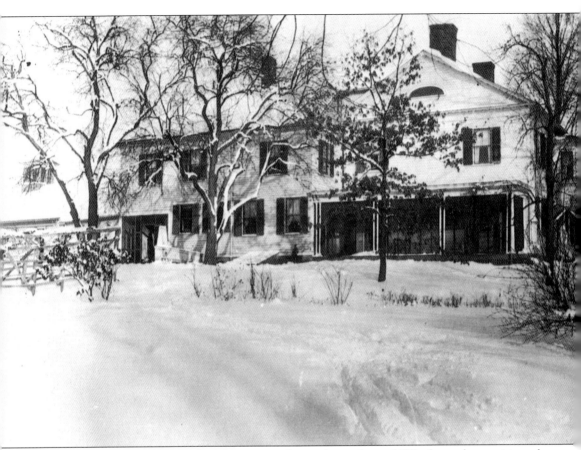

Jonathan Filley and his wife were among the early settlers of Windsor who petitioned the Colonial legislature of Connecticut in 1736 for parish privileges. Over the next two centuries, Filley descendants built homes on the family land, Massaco Farm. This house was built in 1817 by Capt. Oliver Filley and was occupied by several generations of Filleys. It burned down in 1954.

INTRODUCTION

The settlers of the town came from the village of Windsor. Records show that the first explorers of the area reported "good ground sufficient for three families." In 1661, Edward Messenger and his son-in-law, Peter Mills, became the first settlers on this "good ground." Messenger's Farm was on Blue Hills Avenue.

By 1734, families from other communities had found the land "remarkably excellent for agriculture" and had expanded so far into the plain that it was hard for the families to walk back to church each Sunday. A total of 32 heads of families from Windsor, 12 from Simsbury, and 8 from Farmington petitioned the General Assembly of the Colony of Connecticut for permission to establish their own church.

In May 1737, a "Comitey" from the assembly "repaired to ye Parish" and chose a location for the church. By law, it had to be within a few rods of the geographical center of the new parish of "Win-ton-bury."

Within two years, St. Andrew's Church was built in the northern region of what is now Bloomfield. It was only the second Anglican church in the state. The spirit of welcoming and tolerance continues; today, Bloomfield has more than 20 different places of worship.

For 200 years after its founding, Bloomfield remained a rural farming community. Some farms grew huge, many hundreds of acres, as the town's woods were cleared. Other farms stayed small, but almost everyone worked on a farm or had a business to support farmers, or at least kept a garden. That changed by the 1950s.

A hundred years after the founding of Bloomfield, photography was invented. Although we must rely on paintings or written descriptions to know about Wintonbury in the earliest days, in this book you will see photographs that show what the town was like from 1855 to 1955, when it was still a rural community.

Members of the Wintonbury Historical Society have assembled these images of Bloomfield's past with the hopes that you, too, will grow to love the history of this town.

One

HOUSES OF WORSHIP

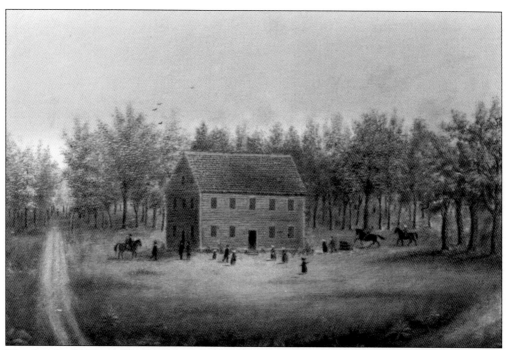

The first building of the Congregational church was dedicated in February 1738, and a new minister, Hezekiah Bissell, Yale Class of 1733, was ordained the next day. He served the church for 45 years, until his death at age 72. The new building was 35 feet by 45 feet. In between the clapboards outside and the pine inside was a layer of bricks in clay. The east door was for women and the west door for men. From his high pulpit in the north end, the minister looked down on the men on his right and the women on his left. The parents looked down on their children, who were seated on log benches in the middle aisle. The church had no heat and no lights, except what came through the two tiers of windows. Swallows nested in the rafters, and squirrels chewed the minister's cushion so that it had to be stored in a nearby tavern during the week. The parishioners endured those conditions for 63 years.

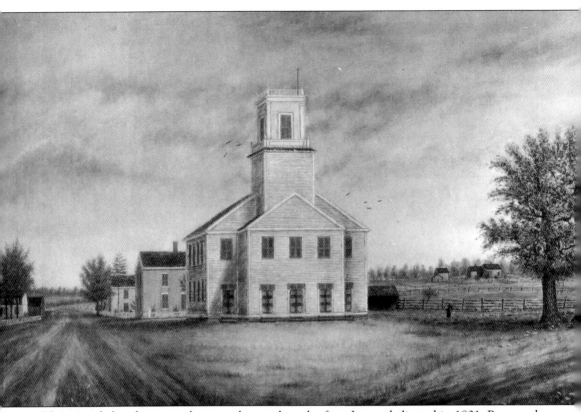

The second church was vastly more elegant than the first. It was dedicated in 1801. Reverend Miller describes the day: ". . . not an empty pew above or below. The countenances of the whole assembly were brightened with joy and naturally brought to mind the rejoicing of Israel when King Solomon dedicated the glorious temple! May the Lord of the temple irradiate this house with the bright cloud of his glory and may it ever truly be found a house of prayer!" Alas, within 56 years, this building had an ignominious ending, being moved aside for a still more glorious building. The old place was used for a dance hall and a tobacco shed before it was torn down.

The third church was built in 1858 for $11,000. It was about the same size as the old church, 50 feet by 40 feet. It once had a slenderer steeple but something must have been wrong with the engineering, because it fell over during the Great Blow of 1862. It was replaced by a sturdier version, which also had a clock, something very convenient for the town before the days of wristwatches.

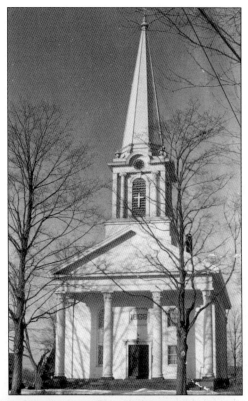

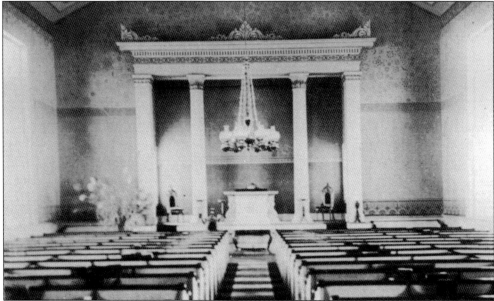

This is the ornate inside of the Congregational church c. 1900. Cushions were now on all the seats. (The coverings have been changed since then, but the stuffing remains the same: corn husks, moss, and 1858 newspapers.) Over the years, the meeting room has grown plainer and plainer, with less decoration, until now visitors often exclaim about its "Colonial" simplicity. In 1738, they would have seen simplicity.

Though there were other churches in town, the Congregational church was the largest and was the social center. These young people and their adult leaders no doubt found fun at Christian Endeavor, but there was a price. Each week a different youth had to give a talk and then lead a discussion of Bible verses.

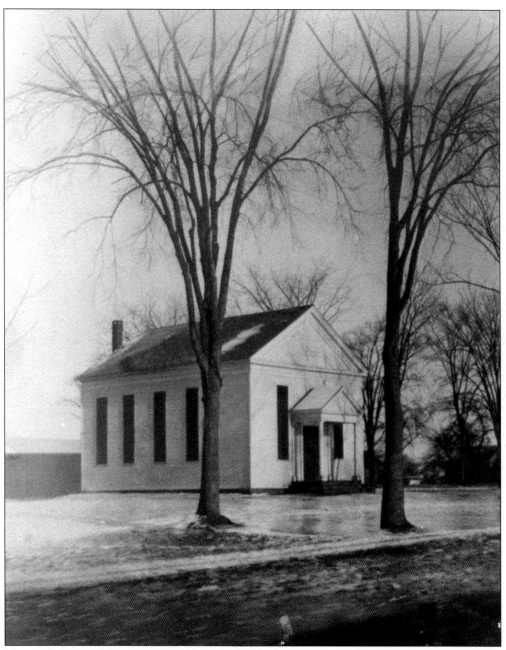

The early years of the Congregational church were not always serene. For some reason now obscured by time, a great conflict arose between the Hubbards and the Gilletts. Deacon Gillett spun off from the Wintonbury church with about 20 others to become a Separatist church, which later aligned itself with the Baptist denomination. The Baptist church was built in 1786 on the corner of Jerome and Park Streets. The church never had more than about 100 members. However, from that church came some of Bloomfield's best: Francis Gillette, who was a U.S. senator, and Virginia Thrall Smith, who founded the Children's Aid Society, which became the Village for Families and Children, and the Newington Hospital for Crippled Children, which has evolved into the Connecticut Children's Medical Center in Hartford.

One legend has it that, in 1835, when Francis Gillette, grandson of Deacon Gillett, read over the charter for the soon-to-be-incorporated town, he crossed out the word Wintonbury, with its connotations of the Wintonbury church, and substituted Bloomfield, a reminder of the blooming fields of the old farms. In 1920, the Baptists moved to 600 Blue Hills Avenue, just over the line in Hartford, and the old building became Boy Scout headquarters until it was torn down in 1924. This church has no connection with the church on Maple Avenue.

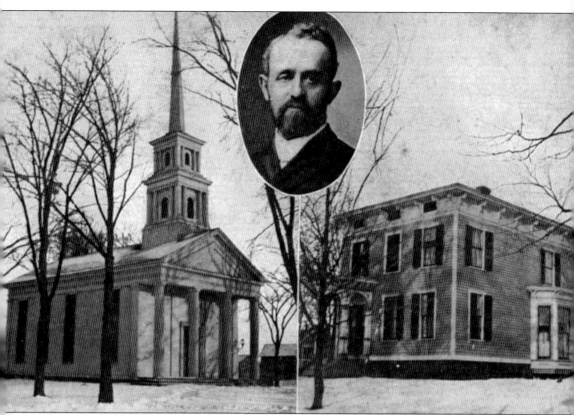

The Methodists first gathered in 1817. Fifteen years later they built a $500 church on Whirlwind Hill. In 1853, they rebuilt it on the corner of Park and Bloomfield Avenues. This time they got much more elaborate and added a second floor, a steeple, pillars, and a portico. This steeple did not last long either, and it was never replaced. The parsonage, next door to the right, was the scene of a four-month revival meeting during which 100 people were converted.

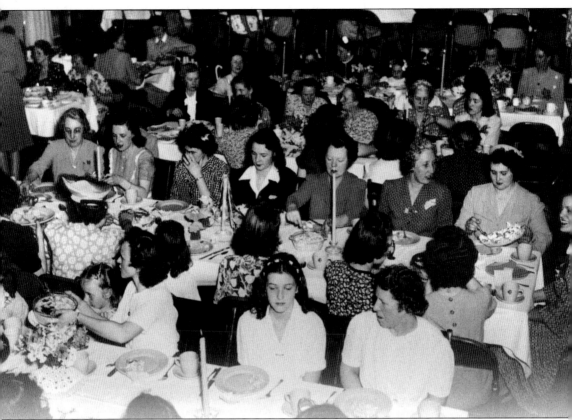

In 1922, the Congregationalists and the Methodists merged to form the Federated Church. The Sunday services, Sunday school for the older children, and the minister's office were in the Congregational church; the younger children's Sunday school, Christian Endeavor, Women's Guild, Men's Forum, Couples Club, Cub Scouts, and social events moved out of the cellar, at last, and enjoyed the light and space of the Methodist church building. This is a picture of a mother-daughter dinner in 1944.

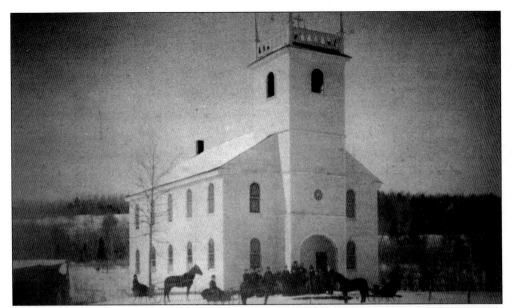

St. Andrew's Church was built just two years after the Congregationalists' first crude church, in 1740. There had been a Church of England congregation in Milford since 1725. The group sent eager missionaries around the state, holding meetings in houses. Inspired, the people of Scotland Parish built this beautiful church, which is still used today. However, it has moved around. In the early 1800s, a Church of England was built in Tariffville. The families who lived farther south wanted to move the church away from the competition and closer to them. Arguments went on for six years, and 50 families left the church. The building was moved to the intersection of Terry Plains and Duncaster but, in 1828, it was moved back to "God's Acre." It is not known whether the 50 families came back, too.

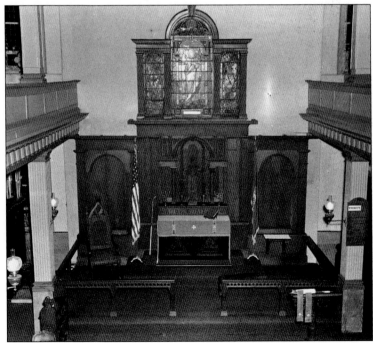

In the 1870s, St. Andrew's had a minister who did wondrous woodcarving. Under his aegis, the nave was beautified.

There were few Catholics in Puritan Connecticut in Colonial days. French missionaries to the Indians held some secret Masses in barns or houses. In the mid-1800s, some of the Irish who fled the potato famine in their homeland settled in town. The first official Mass was held in Bloomfield at the home of James Roche, 60 Wintonbury Avenue. When a small but faithful congregation had been gathered, services were held in the Academy, in the center. This was a mission church and, fasting as they must do before celebrating Mass, the priests came many miles—from either St. Bernard's in Tariffville or St. Joseph's Cathedral in Hartford—to conduct services.

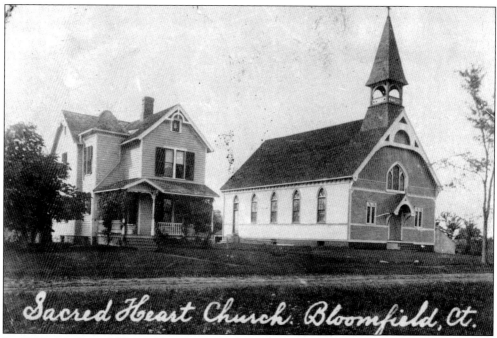

In 1878, this Sacred Heart Church was built on Woodland Avenue. The congregation was small and made large sacrifices to build the church. Using his oxen, Thomas Fagan dug the foundation. When the church was dedicated, it was virtually debt free.

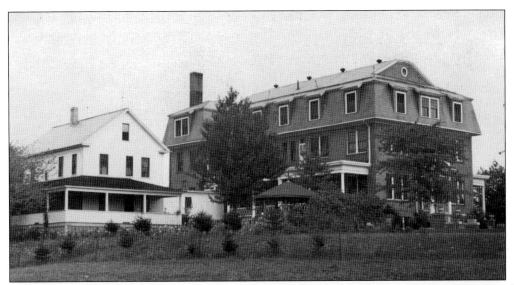

In 1913, the missionaries of Our Lady of LaSalette in Hartford bought Samuel Bushnell Pinney's farm and used the white frame house for outings and for summer retreats. In 1916–1917, the fine brick novitiate was built. To quote from a Sacred Heart publication, "Here in the solitude of religious discipline and farm life, all the classes during a period of almost sixty years were molded and formed, tried and tested for religious profession in the LaSalette Congregation. From this religious house came two bishops, hundreds of priests, and brothers who have gone throughout the world to preach and serve."

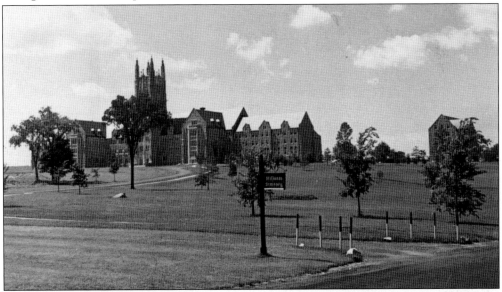

In September 1930, after 32 years of success in Hartford, St. Thomas Seminary welcomed its students to its new campus, on 180 acres off Bloomfield Avenue. These are soaring, spectacular Gothic buildings. Everything is of the finest quality: slate roofs, tiled floors, marble stairs, and oak woodwork. The chapel has stained glass windows from England and an altar from Italy. In 1947, there were 425 young men of high school and college age preparing for the holy priesthood. Cardinal Pacelli visited here just before he became Pope Pius XII. (Karen Carreras-Hubbard.)

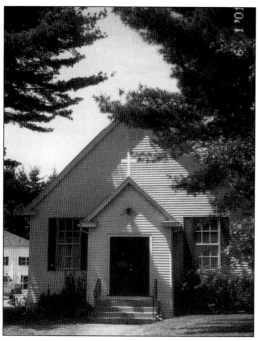

This chapel was built in 1928 on what came to be called Chapel Street. It was a mission church for a while but soon shared administrators with Sacred Heart. It was named Christ the King in 1935. It had a prizewinning Catholic boys' brigade; drills, sports, and social events were held in a large church hall that was added in 1938.

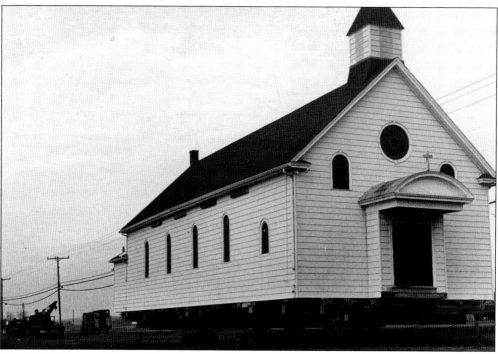

The Catholic population of northeastern Bloomfield grew, as many refugees from Eastern Europe found work in the tobacco fields. In July 1935, the mission church Our Lady of the Assumption was dedicated. It was built by the members of the congregation and seminarians from LaSalette, working together. Eventually, and reluctantly, the congregation was absorbed into Sacred Heart, and the building was moved across the street. Today, it is a retreat center for traumatized children.

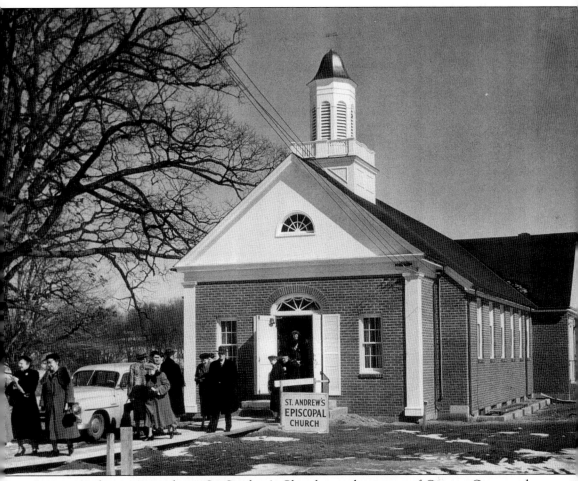

Signage to the contrary, this is St. Stephen's Church, on the corner of Cottage Grove and Bloomfield Avenues. This congregation gathered in 1908 as the Albany Avenue Mission in Hartford. Within two years it was admitted to the diocese as St. Andrew's Church and, in 1952, joined the many who were moving in to Bloomfield. Confusion reigned with two St. Andrew's Churches, so they both changed their names, this one to St. Stephen's and the other to Old St. Andrew's.

The first meeting of the Jewish Community Center was in 1952 at the old Methodist Church, also known as the Federated Church Parish House. In the first floor of a house generously loaned by the Bercowetz family, 50 people decided to start a Hebrew school. In 1955, ground was broken on Blue Hills Avenue for a synagogue to be called Beth Hillel. Then the race began. Lawyers, merchants, and teachers became carpenters, plumbers, and electricians, and the 40 of them worked days and nights to get the synagogue finished for High Holy Days. The building was finished in time, and the services were held for 300 people. They sat on chairs borrowed from Christ the King Church. By 1966, they had outgrown their building, and so they built a new synagogue, shown here, on Wintonbury Avenue.

Two

Scotland Parish

The Talcott Ridge divides the district called Scotland from Simsbury. Perhaps it is also what gave the region its name. The name was used in the 1600s, before any Scottish immigrants arrived. The ridge formed a barrier to travel to the north. In the 1700s, some enterprising men made a road around the side of the ridge and charged a toll for its use. They called it the Granby Pike. We call it Tariffville Road. Notice how all three of the old roads—Blue Hills Avenue, Tunxis Avenue, and Duncaster Road—lead to the pike. In 1835, when Windsor released Wintonbury and it became Bloomfield, the folks in Scotland, then part of Simsbury, asked to join the new town. Even though, in 1843, the Connecticut General Assembly decreed Scotland should be part of Bloomfield, the town kept voting against annexation. The residents did not want the extra 350 people, including children to be educated. Also, almost all of the Scotlanders were Episcopalians.

One of Scotland's borders is the Talcott Ridge, and the other is the Farmington River. The river has had many different bridges. This is how it looked in 1890. It has always been a problem and an expense maintaining the bridge.

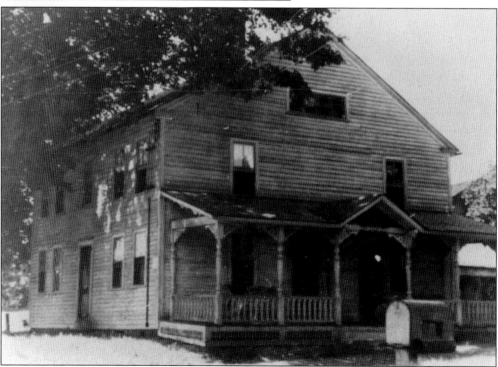

In this house, built by Matthew Adams in 1755, the tolls for the Granby Turnpike were collected. There was also a small store and a tavern, which had been built in 1750. The Adams family kept this farm, which extended down to the river, for almost 200 years. It grew to include three houses, the tavern, a sawmill on the river, horse barns, a sheep shed, and a blacksmith shop. A large brick reservoir held water pumped from a well and then gravity fed to the house and the barns. Hiram Adams, the owner in the early 1900s, was a horse trader. The horses were often transported by train to the nearby station. (Connecticut Historical Society.)

Train service on the Central New England Rail Road started in 1872 or 1873. There were four stations in Bloomfield: Cottage Grove at Goodman Street, the Center, Griffin, and Barnard, or North Bloomfield. At the height of the railroad's success, there were eight trains a day. This shows the last train going through, in 1936. (The Merritt family.)

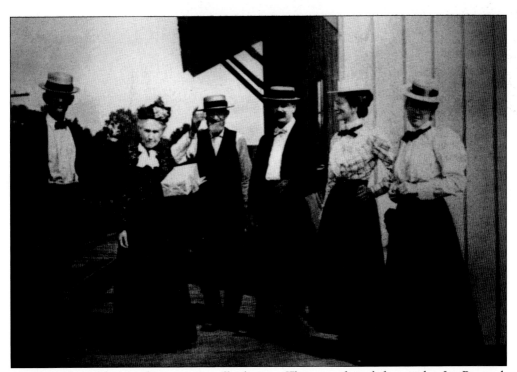

A group of neighbors gathers, seeing off relatives. They are, from left to right, Ira Barnard, Aunt Amelia Barnard of New York, Henry Barnard (Ira Barnard's father), Charles Newberry of Detroit, Nettie Case, and Alice Barnard. (Robert McComb.)

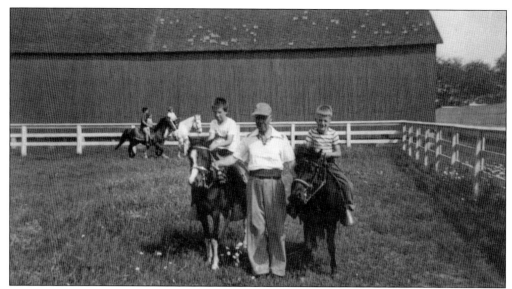

On Tariffville Road, under the shadow of the modern 189-187 bridge, is the house built by Abraham Pinney in 1765. He had four wives and fifteen children. All the children moved west, and a grandnephew took over the farm. That man's son had a disagreement with the owner of the neighboring Hoskins Tavern. He was so cross that he built a "spite barn" right on the edge of his property so that he never again had to look at the tavern from his house. In the 1940s, Helen and Ken French moved their riding stables to the old house. Two generations of neighbor children learned respect, responsibility, discipline, and love of horses thanks to Helen French's goodwill. Neighborhood gymkhanas were a lot of fun for everyone. Shown are Joe Merritt on the left pony, Ken Wheeler on the right, and Ken French in the middle. Joe's parents, Bob and Bunny Merritt, bought Hoskins Tavern and added a pool and tennis courts to make Scotland Parish a paradise in the 1950s.

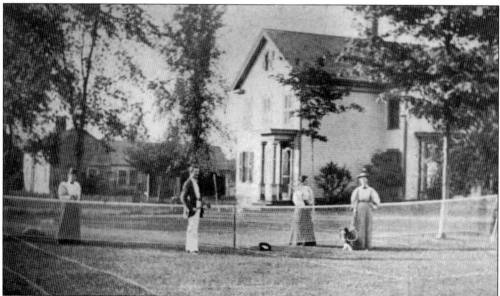

This is the Newberrry-Case house, on the corner of Tariffville Road and Tunxis Avenue Extension. (Robert McComb.)

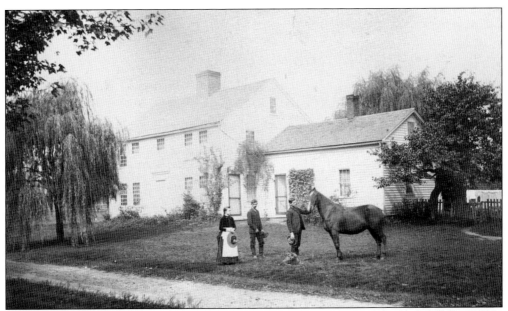

Kitty-corner across the intersection of Tariffville and Duncaster Roads stood the family farmstead of the Barnard family. The big farm's chief crops were potatoes and tobacco. In 1919, this "outdated" house was torn down, to be replaced by a more modern house, complete with oak woodwork. Pride goeth before a fall. Forty years later, the modern house was demolished by the state as part of its new highway project. (The Maden family.)

Up the Granby Pike, as the road starts to rise over the hill, stands the Eliphalet Mitchelson house, built in 1774. Son Ariel Mitchelson was a state legislator, and his grandson Hugh held the first meeting of the Tunxis Grange in that house and was the first master. Next came nephew George, who had already made a fortune out west. He spent his time collecting the many Indian relics that were found in his fields, which sloped down to the Farmington River. He and his wife loved animals—all animals; they had peacocks and tame deer. Mrs. Mitchelson had a pet doe, Dolly, which followed her everywhere. (Robert McComb.)

The first house on the left on Hoskins Road is a small house on what was once a large farm. The six Wasilausky children grew up here. They bought the farm from Cider Brandy Hoskins, and it extended back to the brook and a quarter of a mile along the road. Their cash crop was vegetables, and they had chickens, cows, and pigs enough to feed the family. Shown is Fred Wasilausky, just after pig-slaughtering time, obviously delighted with the musical toy he has made from a string, a stick, and a pig's bladder. (Fred Wasilausky.)

28

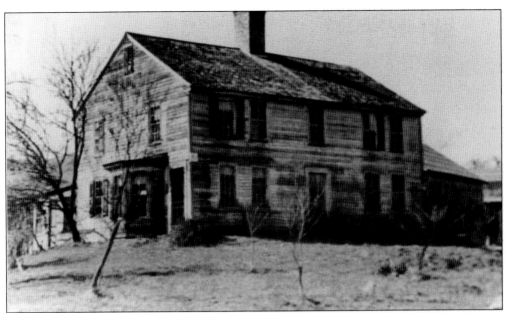

This is where Cider Brandy Hoskins lived, on Hoskins Road, until he died at age 80 in 1943. Hoskins was called Cider Brandy because, of all the cider producers in town, he was one of the most enthusiastic. His hillside was covered with apple trees, and there was a great supply of wood in the forest behind his house, now called Wilcox Park. The house was built by his step-grandfather, Abel Adams, in 1801. (Connecticut Historical Society.)

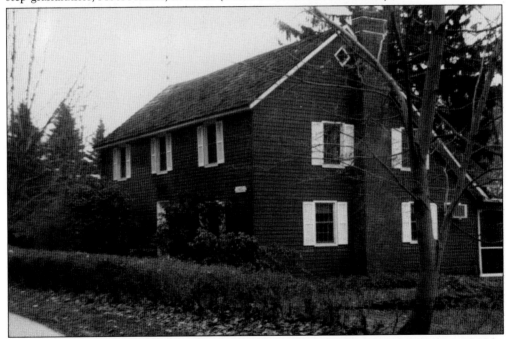

On Hoskins Road is the oldest house still standing in Scotland Parish. It was built in 1745 by Joel Griswold, a cousin of Samuel Griswold, who owned the 500 acres that is now the village of Tariffville but was then called Griswold's Mills. The Griswold expertise was weaving. (Robert McComb.)

On the northwest corner of Adams and Duncaster Roads is the handsome Zelah Case house, built in 1835 of rocks quarried on the farm. The farm stretched a mile along Duncaster. Zelah Case's cash crop was tobacco, but each week he took the extra butter and eggs by oxcart into Hartford to sell.

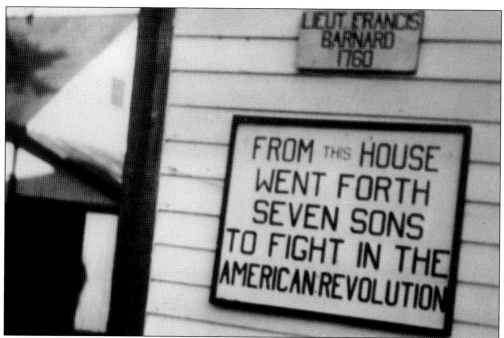

On the southeast corner of Adams and Duncaster Roads stood a house that was a famous landmark. It was built by Lt. Francis Barnard in 1760. This is the sign that made the house famous. Of course, things were much more informal in the Revolutionary War. Enlistments could be for as little as a day. So, do not visualize all seven sons marching off together to stay for the duration of the war.

Three

TAVERNS AND INNS

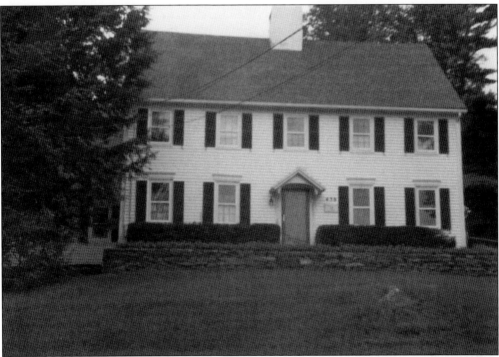

Innkeeping was an honorable profession. Innkeepers were chosen by the town and, later, were licensed by the county court. Wintonbury's location made it an ideal place for a stop on stagecoach, oxcart, horse, or foot trips to or from Hartford. As early as 1700, this location was the headquarters of the Hartford-to-Westfield stagecoach. In 1830, the building, on Simsbury Road, was remodeled by Joseph Prosser to become the Prosser Inn. In what was surely a quixotic act for a tavern keeper, Prosser and the Congregational minister, Mr. Barber, formed the first Temperance Society in town, meeting here. It was not at all popular with those cider brandy producers, and Prosser writes that they "were not allowed to transact their business in peace."

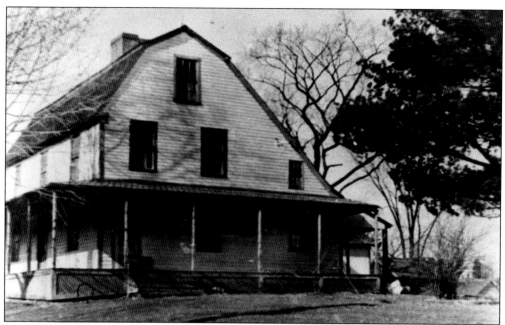

Joseph Goodwin built this house in 1746 near the south end of Duncaster Road. It had a 40-foot kitchen with a fireplace that was 8 feet by 6 feet by 3 feet. There were only two bedrooms upstairs, but they were huge. Speaking of huge, most of the cellar wall was made of stones 6 feet to 8 feet long.

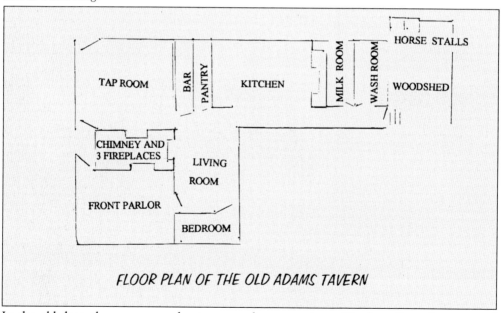

FLOOR PLAN OF THE OLD ADAMS TAVERN

In the old days, there was a road going over the mountain to Simsbury from the corner of Adams and Hoskins Roads—an ideal place for this tavern, built in 1750. The date is confirmed by a bronze plaque announcing that the tavern had fire insurance with Aetna in 1750. Before the U.S. mail service, inns were depots for one kind of mail delivery. People would leave their letters in a box over the living room fireplace and some kind soul would take them to another inn en route.

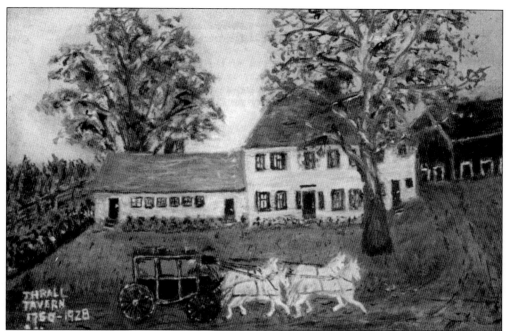

Thrall Tavern, built *c.* 1760 by Oliver Thrall, was well located on the main road from Hartford, now Blue Hills Avenue. This picture was painted from childhood memories by Annie Haun. The tavern was later called the Buttonball Tavern for the huge sycamore tree in its yard. In 1824, Lafayette was entertained here with about 100 of his men.

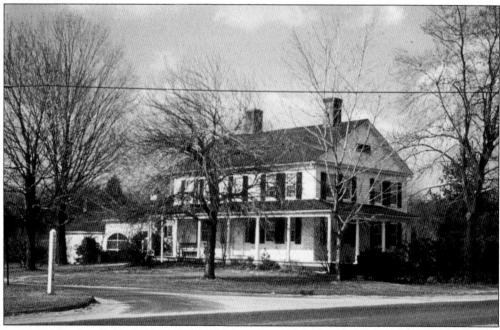

In 1832, Rockwell Hoskins built his fine tavern on the corner of the Granby Pike and Duncaster Road, an ideal stopping place for the eight-hour trip from Westfield to Hartford. The second story contained a large dance hall. Folks seemed to do a lot of dancing in the good old days.

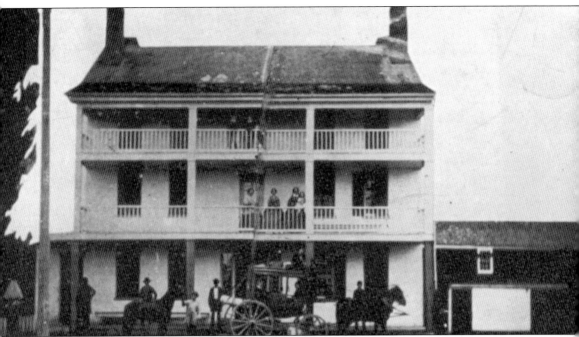

Since earliest times, there was a tavern in the center of town. Perhaps this *c.* 1790 building was a tavern, too. In 1858, Edwin Brown and Alfred Griffin bought it and changed the name to Brown and Griffin Tavern. The stagecoaches all stopped here. The *Hartford Courant* and the U.S. mail were distributed from here. These fine old hostelries all seemed to close about the same time. The coming of the railroad in 1872 meant no more stagecoach stops. Another factor was temperance. In 1839, the Connecticut General Assembly enacted a law prohibiting the "Sale of Spiritous Liquors." Defiantly, the town held a meeting and voted that "All voters were licensed to sell wines and spirituous liquors at their home or places of business." However, by 1870, there was only one cider distillery left; on Friday, September 13, 1873, Bloomfield went dry and much of the revenue of the taverns dried up, too.

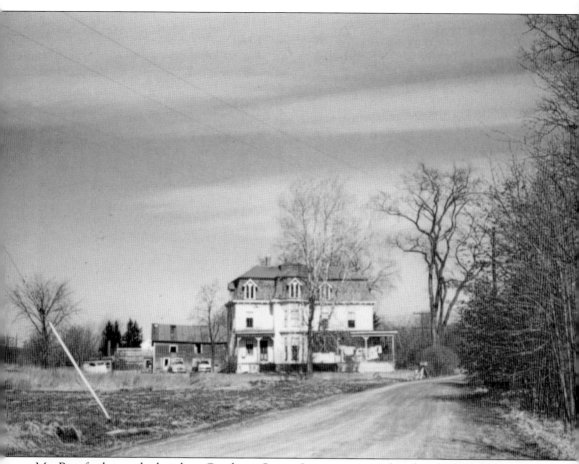

Mr. Beauford owned a hotel on Goodman Street. It was a summer hotel with about 10 rooms. He advertised it in New York newspapers as being "In the country, right on the train route. Private bathing for men and women." It was right at the Cottage Grove Station, but the only bathing was at the brook—a clump of bushes for the men, a clump of bushes for the women. There were snakes. The hotel was on a 100-foot lot, but it had a 20-foot by 20-foot dancing pavilion, surrounded by screens. By the light of oil lamps on poles and, later, Japanese lanterns, couples danced to Victrola music.

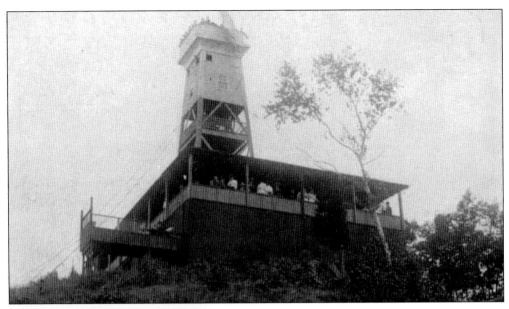

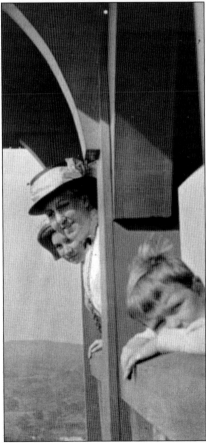

This is one of the four Bartlett towers built along the ridge of Talcott Mountain. The scene to the left pictures visitors at the northmost tower, located on the ridge above Old St. Andrews Church. Families, couples, clubs, and church groups took the railroad out to the Tower Station. To quote from a newspaper memoir, "Boy! It was a stiff climb from the little station up to the Tower but it was worth it! Such air and such scenery . . . Looking down upon the river from the tower with the sun shining on the turbulent water below likening it to a shimmering moiré sash. . . . To the north was Copper Mountain, to the east, a bunch of Granbys, to the south, the view of Hartford intrigued me as the Asylum Hill Congregational Church looked like it was connected to the rear of Saint Joseph's Cathedral." Surrounding the tower was a fine pavilion, full of fancy furniture, with piazzas (porches), a dance floor, and a bowling alley. There was a lovely picnic grove with tables, swings, seesaws, and places for croquet and quoits. Further memories ". . . the afternoon was spent in dancing (to piano playing), and yelling ourselves hoarse singing college songs, one of the girls recited, and one of the men danced jigs to the tune of Swanee [sic] River." When the tower—unused for years, outshone by more modern amusements—burned one night in 1946, the roosters in nearby farms woke up and crowed, thinking it was dawn, and many hearts with happy memories were saddened.

Four

School Days

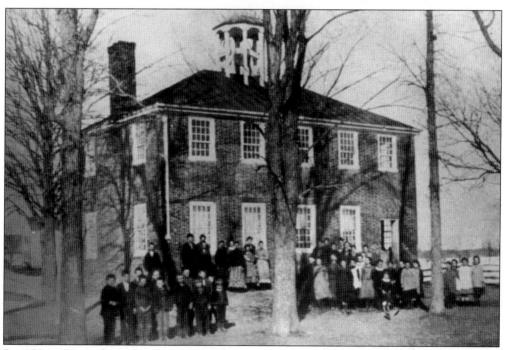

By 1796, Wintonbury Parish was divided into seven districts under the control of the Ecclesiastical Society of Wintonbury Parish. By 1796, five schools had been completed, including the Old Farm School. The Old Farm School, the oldest public building in Bloomfield, is still standing. It replaced an original log building, which had been used as both a school and a meetinghouse. The Old Farm School functioned as a school from that date to 1922, when the Blue Hills Grammar School was completed. When School Street was realigned, it was necessary to move the building across the street. This was accomplished through the cooperation of the Wintonbury Historical Society and the town. The school is maintained by the historical society and is open to the public on Sundays during the summer months. This view shows the school in 1877, at its original site. The building bears a striking similarity to authentic Charles Bulfinch designs.

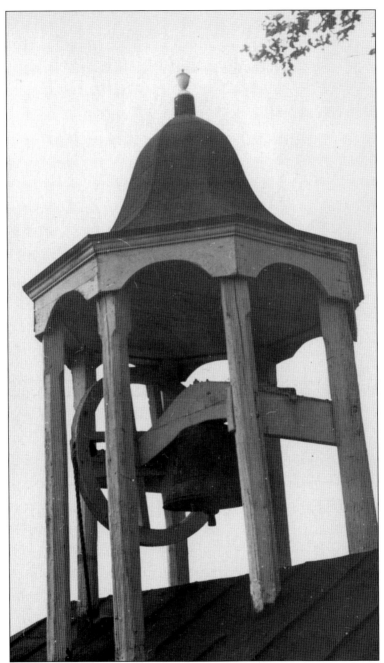

The Old Farm School served as a focal point at Bloomfield's tercentenary in 1936, and this interesting description of the old bell atop the school was provided at that time: "This beautiful bell flares to a circumference of 46 inches at its lower rim, its diameter at the top being 26 inches and its tongue measurement is nearly two feet long. Around the bell's outer surface are five ridges whose appearance gives indication that the bell was molded in one piece. . . . Within two of these ridges near the top of the bell appear the numerals 1796." The bell was presented by Frederick Bull and was first rung in 1797 at his death. It continues to ring today, its tone beautifully mellowed by age.

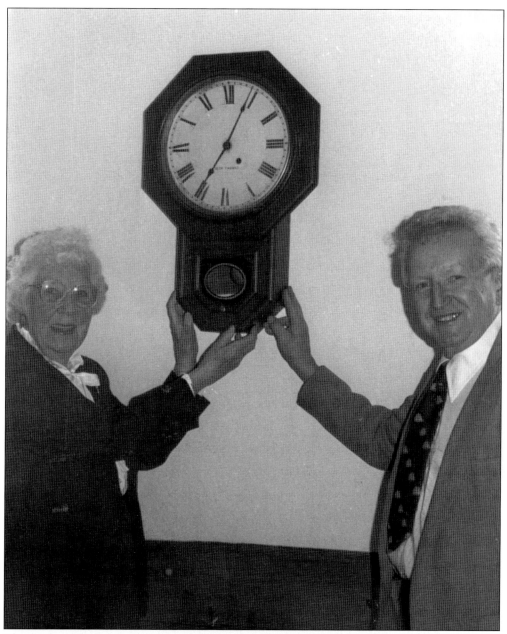

The final touch: the original school clock is installed. Pictured are two very active members of the Wintonbury Historical Society, Ellen Breining, who served as Bloomfield's postmaster for many years, and Charles Walker, president of the historical society at the time.

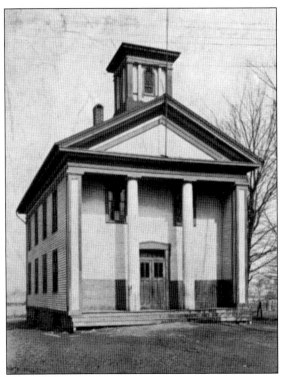

The Academy was built in 1854 by private subscription. It flourished as a private school for a few years, with Nathan Miller as chairman of the board of trustees. However, classes were discontinued before 1870. In 1873, the Old Center School, on Whirlwind Hill, was abandoned and a committee of Eli Brown, Henry Rowley, and Henry Cadwell was appointed to purchase a schoolhouse. Two weeks later, the committee was authorized to pay $1,500 for the "Academy grounds and buildings therein and appurtenances thereof." The Academy was in use as a public school until June 1929.

BLOOMFIELD ACADEMY.

The Trustees of this Academy would announce to the inhabitants of Bloomfield and vicinity, that the Summer Term will be opened, Monday, May 12th, under the direction of

PHILIP B. SHUMWAY,

as Principal.

TERMS OF TUITION.

Common English, - - - $4.50
Higher English and Mathematics,
 Ancient and Modern Languages, 5.00

Payment to be made at the middle of the Term. No deduction unless in case of sickness, or by special arrangement.

N. F. MILLER,
Chairman Board of Trustees.
Bloomfield, Conn. April 29th, 1862.

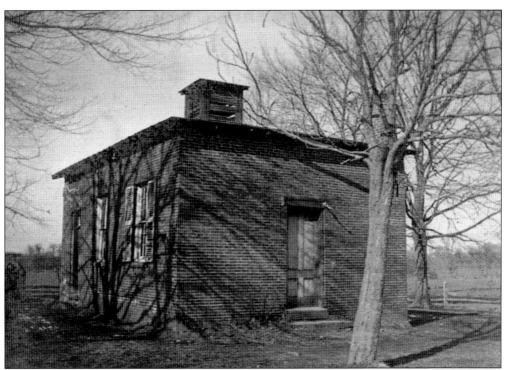

The South Middle School, built in 1796, was located on the north side of Cottage Grove Road.

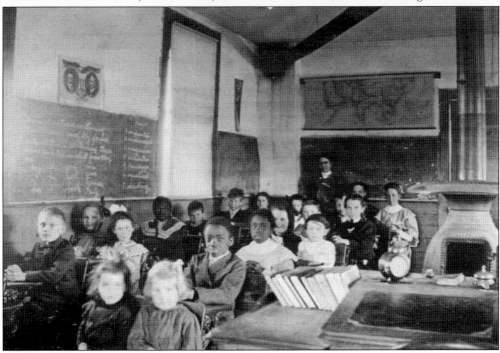

This is an interior view of the South Middle School. The teacher in the back of the classroom is believed to be Delia Lagan, who taught at the Center Grammar School for many years after the regional schools were closed.

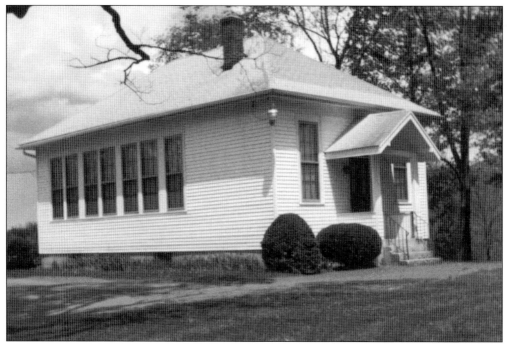

The Duncaster School was built in 1926, replacing an earlier building, which was moved to West Street and became a residence. The building and grounds are now owned and well maintained by Tunxis Grange No. 13.

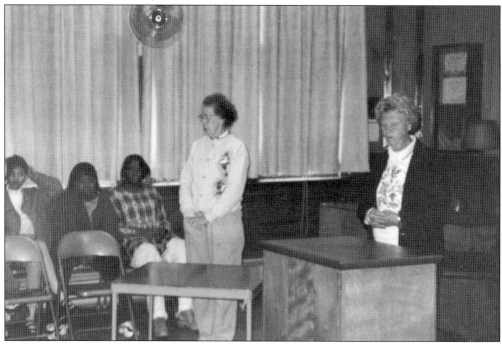

Shown giving a bit of history to present-day Bloomfield students are Joan Hocking Goetjen and her sister, Phyllis Hocking, both of whom attended school here and were active Grange members.

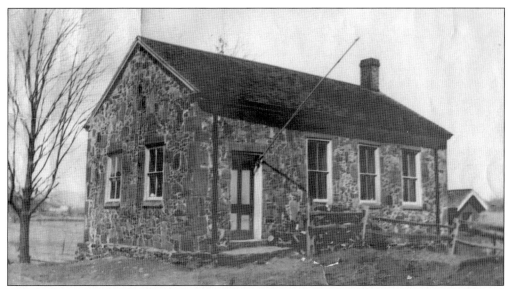

The Southwest District School, on Simsbury Road, also called the Stone School, was erected in 1858 by workers from David Grant's Poor Farm. It has been placed on the National Register of Historic Places and is maintained by the Wintonbury Historical Society.

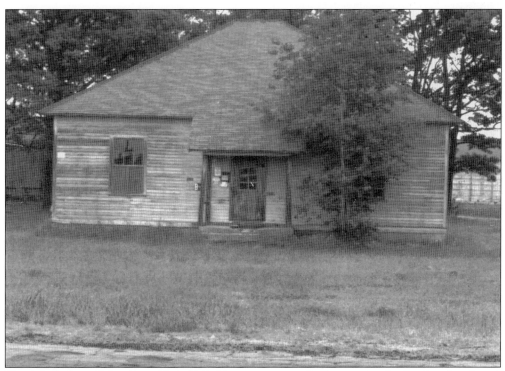

The Mitchelson School, on Blue Hills Extension, was the last regional school to be closed. Why? Because the road was too muddy for the school bus to get through.

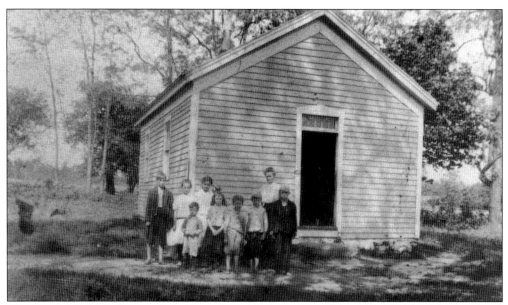

The Scotland North District School was located on land once owned by George Mitchelson. It was "built by subscription of $5.00 per share." Ambrose Adams, Abel Adams, Ariel Mitchelson, and Joel Griswold were the committee members. In 1930, the school's pupils were transferred to the brick schoolhouse pictured below. The older school now stands on part of the historical complex of the Simsbury Historical Society, on Hopmeadow Street, Simsbury. (Sally Cowles.)

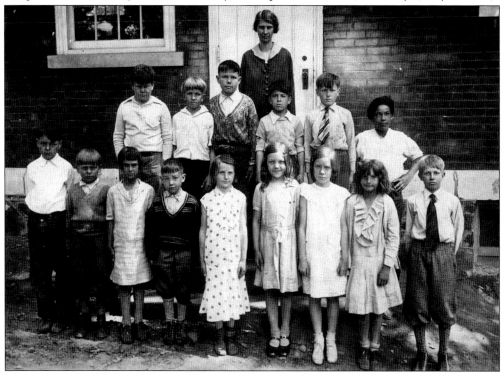

This brick schoolhouse was closed in 1932, after its pupils were transferred to the Center Grammar School. It was later converted to a private residence. (Fred Wasilausky.)

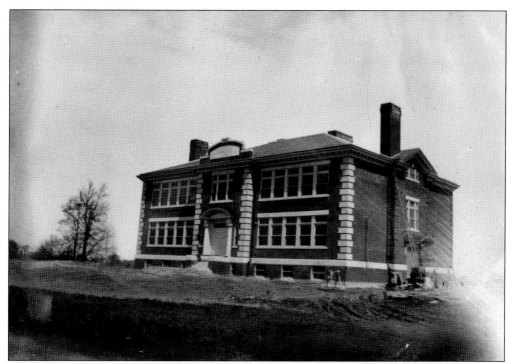

The Center Grammar School, on Jerome Avenue, was built in 1913 and was used until Metacomet School was completed, in 1961. Classes from first grade through high school were taught here. In 1962, the Prosser Library moved into the second floor while a new library was being built. Only three weeks after the move, however, the building burned down.

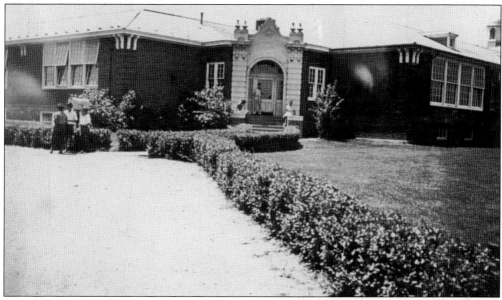

In 1922, the Blue Hills Grammar School was completed. Beatrice (Farnham) Noyes, who taught the last class at the Old Farm School, transferred to Blue Hills. She taught primary grades at Blue Hills for many years. Grades one through eight (with kindergarten added later) were taught, and the pupils then transferred to Bloomfield High School.

Enjoying a picnic together are the faculty members of the Blue Hill School. Frances Robinson, left, was affectionately known as "Robbie" to her many pupils. She served as principal of all the grades for many years. As the school grew, she was named principal of the junior high and William Johnson, foreground, became principal of kindergarten through grade six.

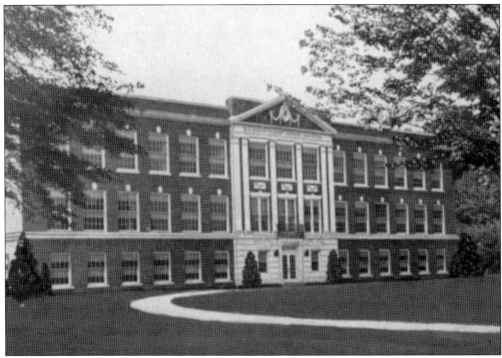

This school was constructed in 1929 and was replaced in 1956 by a new high school, built at a different site. Much to the dismay of its generation of graduates, this building was destroyed to make way for a new police station.

Shown is B.J. Lee, beloved principal of Bloomfield High School for many years.

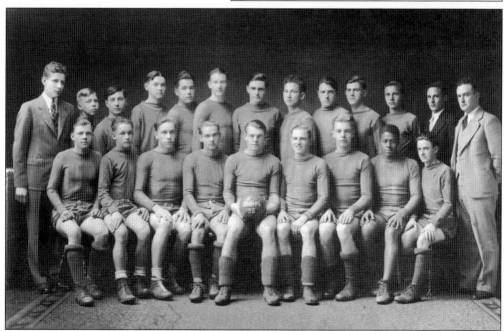

This sports news appeared in the November 28, 1932 edition of the *Hartford Courant:* "The Bloomfield High School soccer team nipped Wethersfield 1-0 to win the Central Valley Conference Championship."

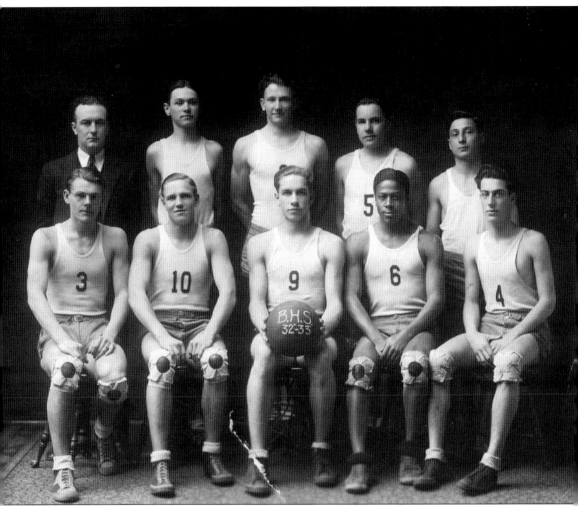

The Bloomfield High School basketball team of 1932–1933 came close to winning the championship: the team was runner-up to Wethersfield. Shown, from left to right, are the following: (front row) Allen Birch, Harry Larensen, Allen Loeffler, Moses Wimbish, and George Trombley; (back row) Coach Serjus Bernard, Walter Ostapkevich, Thomas Burnham, Norman Hubbard, and Ernest Ferraresso.

Five

EARLY FARMS
AND INDUSTRIES

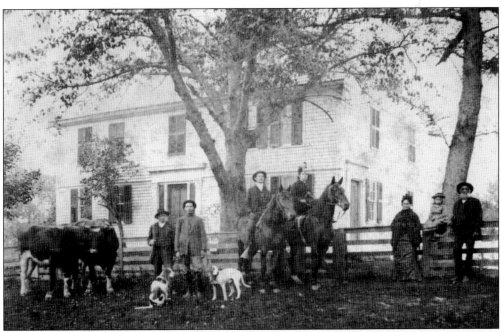

The Wilcox homestead stands as an example of the early settlers' rural roots, reliance on the self-sufficiency of the family, and the creative ingenuity of Colonial men and women. Long before the Revolutionary War, Daniel Wilcox came to the section of Bloomfield just off what is now Duncaster Road to build his home and farm. He also built a sawmill, gun mill, and blacksmith shop. He was one of the first to make bear traps, starting in 1760, but he changed to making guns for the Revolution in 1775. The property was owned and occupied continuously by direct descendants of Wilcox from 1770 until it was sold to Dr. Swett in 1925. This picture, taken in the mid-1800s, shows members of the John Wilcox family and neighbors.

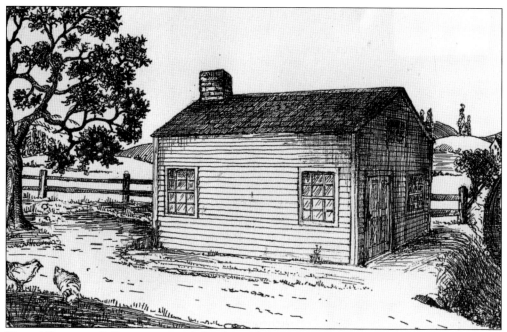

Eli and Benjamin I. Brown operated this drum shop on Brown Street in the early 1800s.

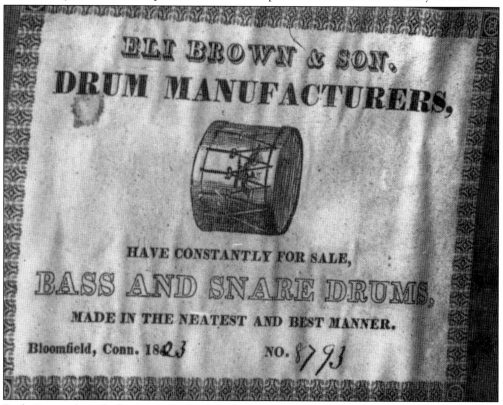

Each Brown drum had a label inside with the name of the manufacturer, the date produced, and the drum number for that year.

These Barton sleigh bells were molded in one piece, an art first practiced by William Barton, an early craftsman who worked with metals in his shop on Park Avenue near the center of town. Barton, who cast the first sleigh bells in the United States, turned to manufacturing pistols during the Revolutionary War. (Anne Rideout.)

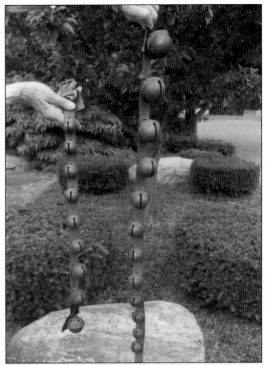

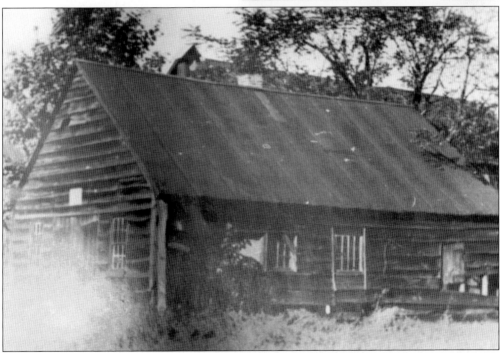

Oliver Filley operated this tin shop on Brown Street near the intersection of Mountain Avenue. Filley's tinware business boomed in the years following the War of 1812. Among his products exported were pails, cups, dippers, kettles, coffeepots, candlesticks, and boxes—some of the many wares that the famous Yankee peddlers sold on their wide-ranging travels.

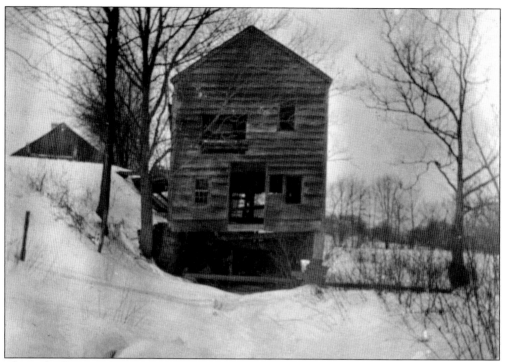

The Bidwell Sawmill was built in 1775 and was operated by the Bidwell family for more than 100 years. It was located on the south side of Wash Brook on Bloomfield Avenue, approximately across from Oak Lane. It was destroyed by a flood in 1907.

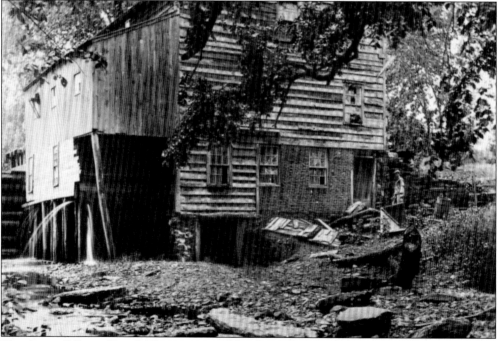

The Amos Gillette Grist Mill was operated by the Gillette family from 1780 to 1865. It was located on Wash Brook, south of Cottage Grove Road, almost opposite Prospect Street.

The Woodford Farm was located on School Street. This 1896 view shows the two new barns that replaced ones that had been destroyed by fire. Members of the Congregational church gave a barn-warming ice-cream social for the Woodford brothers, George and Sydney, and the evening was spent eating ice cream and singing. Jeremiah Woodford cut the trees to clear the land and made timbers to build the house and barns in 1817. As workers tilled the land for the first time, children followed the plows and picked up various Indian artifacts. The farm was operated for five generations by direct descendants until 1988, when the dairy barn and house were destroyed by fire.

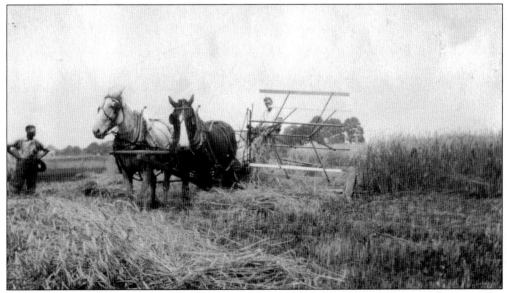

Harold Woodford drives the team of horses pulling the machine that threshes the rye. This photograph was taken c. 1912.

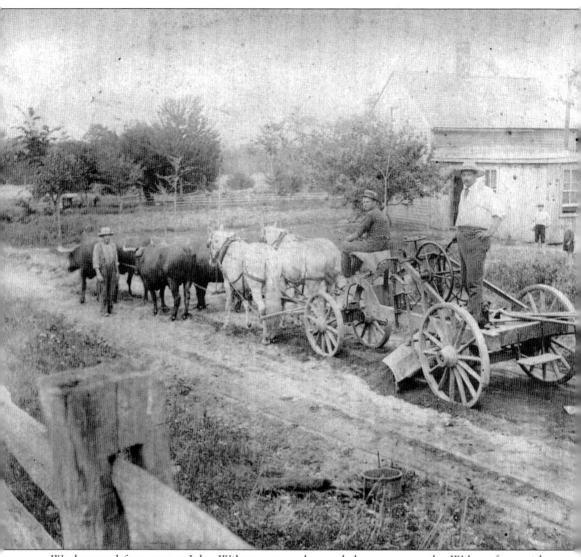

Workers and farm owner John Wilcox scrape the road that connects the Wilcox farm with Duncaster Road. It is unusual to see farmers using oxen and horses together to pull any kind of equipment, but this heavy machine requires a strong pull.

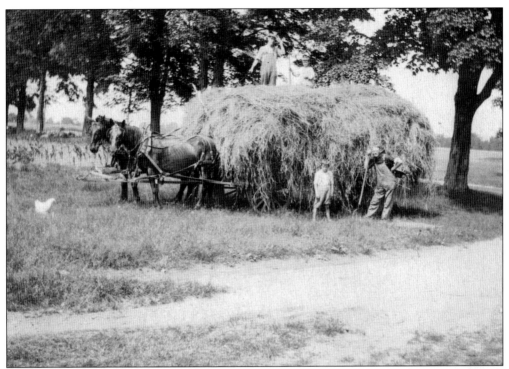

Farmhands are shown haying on the Eddy farm in the early 1900s. Little Dave Eddy stands with the hired man, leaning on the pitchfork, taking a brief rest. (David Eddy.)

Charles Eddy stands ready to drive his Buick milk truck to deliver milk to Hartford residents in 1917. His son, David Eddy, and some cousins stand beside the Model T Fords. (David Eddy.)

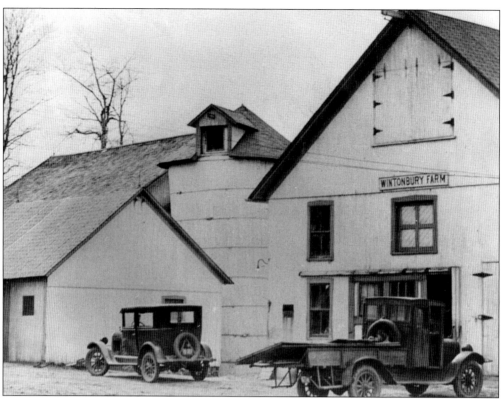

The Wintonbury Farm, owned by the Barnard family, was located on the corner of Gabb Road and Bloomfield Avenue. (Cynthia Barnard.)

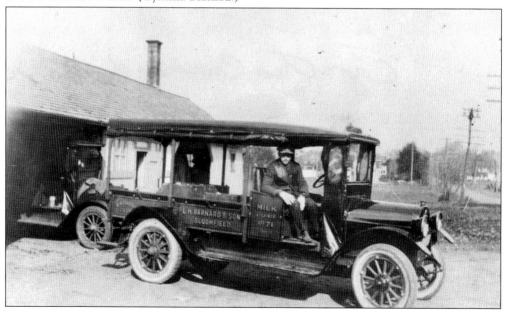

Raymond H. Barnard Sr. sits in his delivery truck, parked in the yard of his Wintonbury Farm in 1923. The truck lettering says, "Wintonbury Farm, L.H. Barnard & Son, Bloomfield, Milk License No. 71." (Cynthia Barnard.)

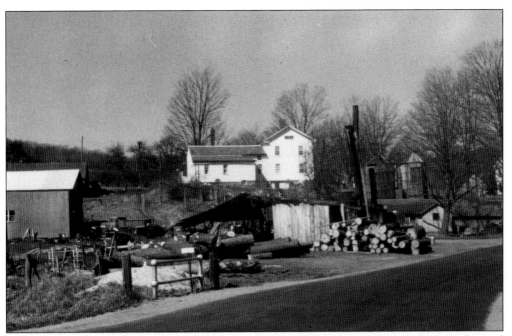

Seven generations of the Moore family have lived on the same piece of property, located on Mountain Avenue at the junction of Duncaster Road. The Moore family started a sawmill and lumber business c. 1875. At first, horses pulled the portable sawmill into the woods where the trees were. Ivan Moore operated two portable sawmills in addition to the steam mill until 1969.

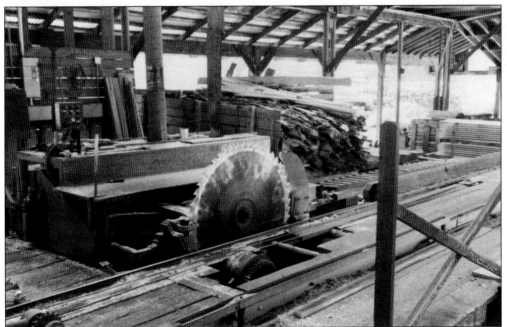

Today, Donald Moore and his sons, Jim and Doug, who represent the fifth generation of Moores in the lumber business, operate a modern sawmill plant with two new buildings, the first with an electric-driven sawmill, pictured here, and a new storage building.

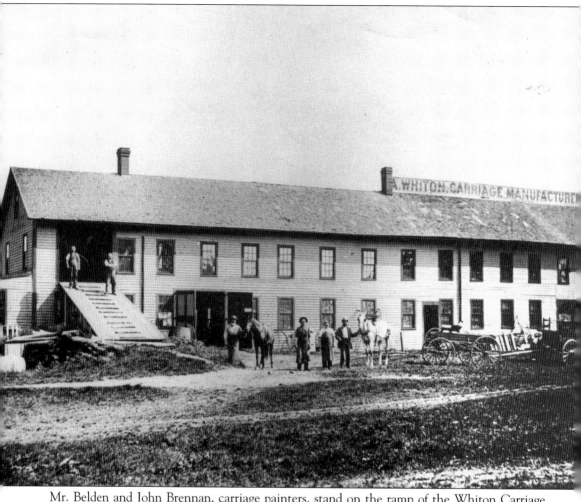

Mr. Belden and John Brennan, carriage painters, stand on the ramp of the Whiton Carriage Shop in 1890. On the ground are shop owner Augustus Whiton, Tom Wall, and Lorenzo Dunbar. The man with the horse is unidentified. Whiton, a blacksmith, moved to Bloomfield in 1843 and began a blacksmith and steel yard business. Tudor Whiton, his son, a Civil War veteran, was associated with him. T. Whiton Wagon Works became well known throughout the state. The building was located where the Wintonbury Mall is today.

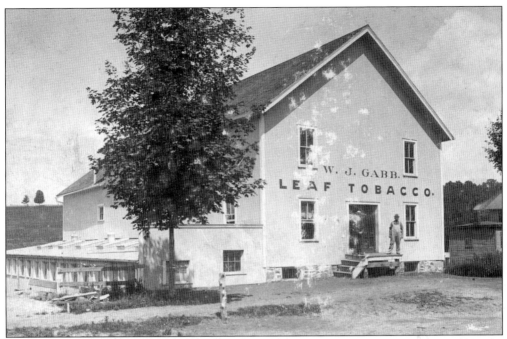

Long before the colonists arrived, Native Americans harvested tobacco, which grew wild in the rich soil along the riverbanks. Many Bloomfield farmers included a field of tobacco among their varied crops. Gabb's Warehouse stands as an example of the popularity of growing leaf tobacco. The building, erected in 1892, was on Tunxis Avenue where the Masonic Hall now stands.

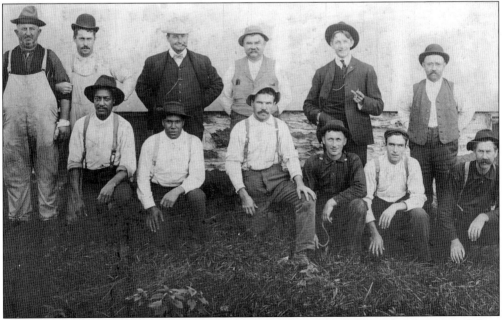

Shown are employees of W.J. Gabb Leaf Tobacco Company c. 1905. They are, from left to right, as follows: (front row) Clint Mills, Oscar Mills, Charlie Albert, Ed Green, Jim Cahill, and George Riley; (back row) W.W. Allyn, C. Dwyer, Herman St. John, Judge Murray, Sheriff George Gabb, and John McCormick.

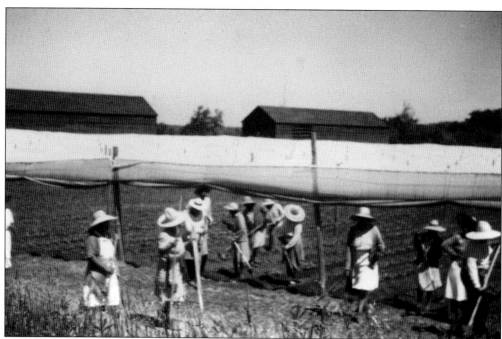

The popularity of tobacco crops created a high demand for laborers, drawing farmers, local youth, and migrant workers from the South.

The ripe tobacco awaits the leaf pickers. This picture shows the nets, damaged by a hailstorm, just one of the many problems facing growers.

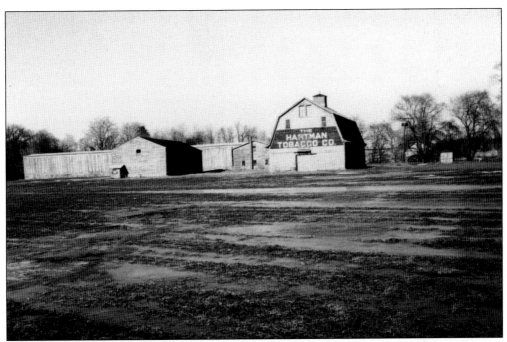

The Hartman tobacco barns are located in North Bloomfield. A special shade tobacco is still grown in Bloomfield for some of the finest cigars. Culbro, Hartman, and General Cigar Companies still produce tobacco here.

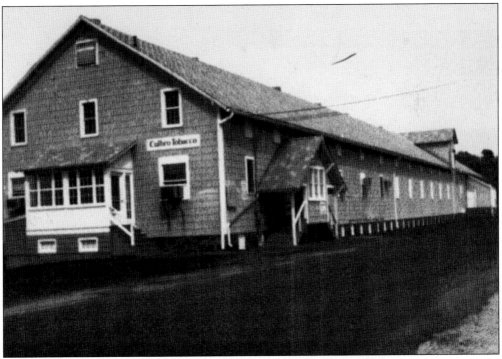

The Culbro Warehouse is located at Griffin Station, North Bloomfield.

This orchard once was part of the Henry Rooke farm, located on Duncaster Road across from what is now the Grange Hall, formerly the Duncaster School. Rooke's russet apples made good cider, which was pressed at the cider mill on Mountain Avenue, near Moore's Sawmill. Rooke peddled the cider, fruit, and other farm produce on his twice-weekly route to the city. He started peddling when he was in his early 20s and continued until age 96—nearly 75 years in all.

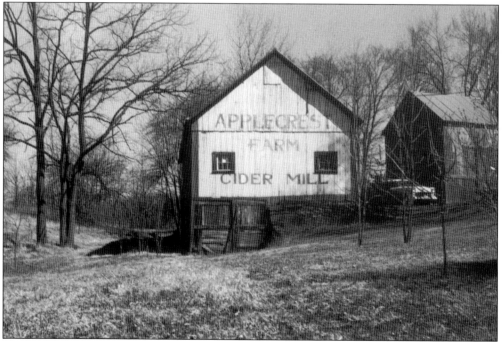

The Applecrest Farm Cider Mill is clearly identified.

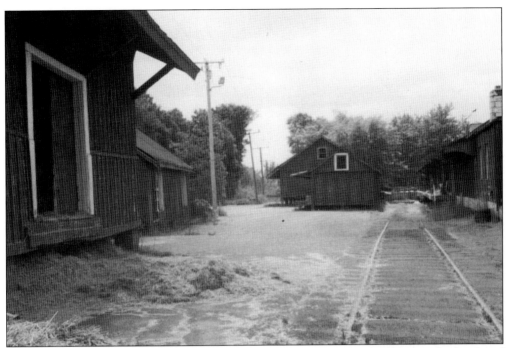

The Bloomfield Farmers' Exchange, located on Jerome Avenue, has buildings on both sides of the railroad tracks. Rail cars bring supplies, in bulk, right up to the sidings to be unloaded. The Farmers' Exchange, organized in 1920 by a group of local farmers, is the oldest continuous retail business in Bloomfield.

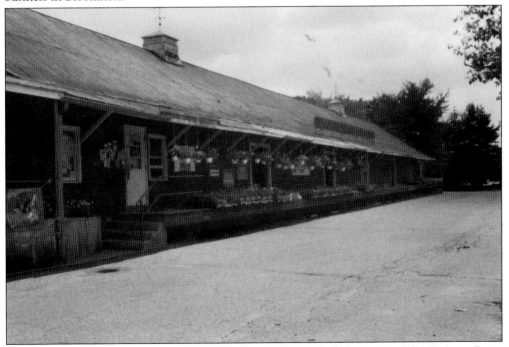

In 1921, the Farmers' Exchange purchased the warehouse and business of the Everett Grain Company. There have been many additions, both in buildings and in business, since that time.

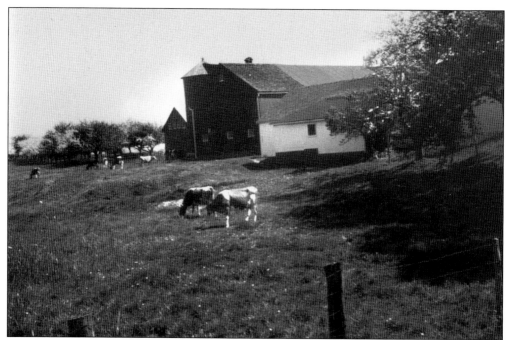

This farm, originally built by Jonathan Gillett in 1800, has had several owners. From Gillett, it went to his son, Johnson Gillett, and then to Johnson's daughter Katie and her husband, Edgar Pinney. Walter Scott owned it next, and he rented it out to the Lagan family. Willie Hubbard, a hardworking farmer and Bloomfield businessman, bought it in 1906 and farmed until 1952, when the property was sold to the Schiff family. Currently, the farm is called Bloom Hill and is owned by Miro Miroslav and Kathy Palascak.

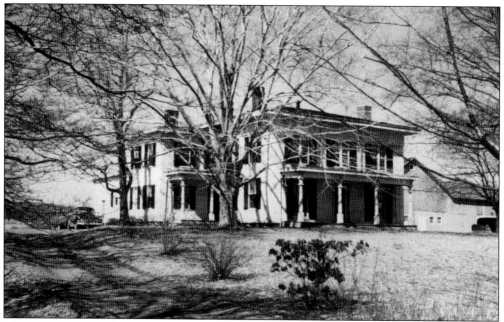

The old Willoughby homestead dates back to 1840. Although the farm no longer operates, the home still stands on Woodland Avenue.

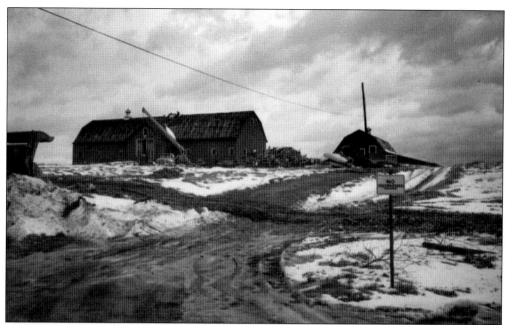

The barns on the hill on Wintonbury Avenue are being torn down to make way for the Seabury Retirement Center. The Christensen family originally operated this farm. A.C. Peterson bought the land, improved it, and added to the barns. He eventually sold the property to Seabury.

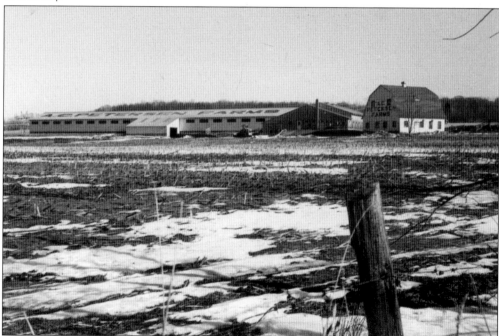

Christian Peterson originally owned this farm on Terry Plains Road. He sold it to a Dutch organization, and the farm became known as the Imperial Farm. In 1946, A.C. Peterson acquired the farm, and it became the heart of Peterson's farming enterprises until it was sold to the town of Bloomfield for a golf course.

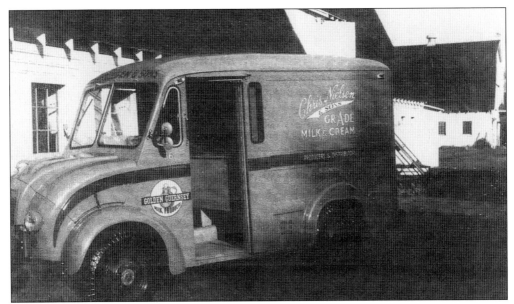

Twelve years after he arrived in Connecticut from Copenhagen, Denmark, Christian Nielsen bought the Barber Farm, at the corner of Hall Boulevard and Simsbury Road. Thus, in 1912, a true family business was launched and it grew, prospered, and provided for the six boys and two girls that made up the family. Buildings were enlarged, milk routes were expanded, and the farm's ice cream became a favorite treat for many people. Overcoming hardships and fires, the business grew and became a source of pride. In 1973, the dairy was sold to the Connecticut General Company.

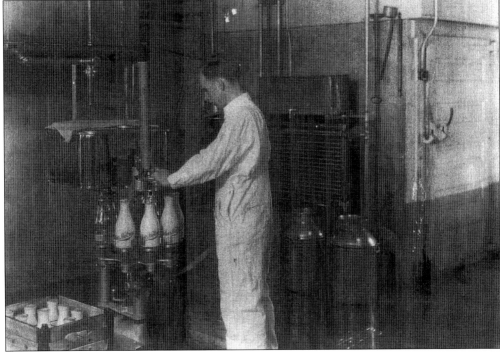

Carl Nielsen is shown bottling milk during the early days of the operation. (Donna Nielsen.)

Wade's Vegetables started as a small dairy farm at the corner of Mountain Avenue and Simsbury Road. In 1919, Mr. Wade sold fresh vegetables at a little stand by the side of the road. Corn was his main product, but his wife's homemade pies were a specialty. The present owners, son Ron Wade and his wife, Claire, have developed the business to include over 200 acres of land under cultivation, producing vegetables sold wholesale, as well as in their fruit and vegetable store.

The dairy herd of Howard Nielsen was housed at the old Christensen farm on Woodland Avenue during the early 1960s. (Mr. Christensen.)

When Bloomfield had more cows than people, cattle were unloaded from the Griffin Line railroad cars and driven to the Kalman Bercowetz farm. In 1909, Kalman Bercowetz, a Russian immigrant, acquired 100 acres of farmland bordering Cottage Grove Road, on Goodman Street, a road that ended at the railroad tracks. There, he raised five children and realized his dream of owning a successful farm and slaughterhouse. With the help of loyal family members who practiced the same attributes of frugality and hard work that Bercowetz taught them by example, the business grew beyond his wildest dreams. Where once huge fields of corn and a small barn stood, the Copaco Shopping Center now bustles with activity. (B. Bercowetz.)

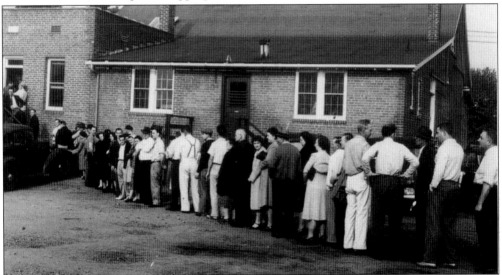

During World War II, meat was rationed and frequently very scarce. However, the Bercowetz family could be counted on to supply quality meats at reasonable prices. Customers often had to line up and wait their turn to enter the little meat store, pictured on the left. On the right is the building used to cut and prepare the meat, and the original slaughterhouse is behind that building. The Bercowetz family formed the Connecticut Packing Company, or Copaco, and served as leaders in the progress and economic changes that occurred in town after the war. From the 1950s on, Bloomfield's farms began to disappear to make way for the housing developments and business ventures that saw Bloomfield as fertile ground for new industry and business. (H. Bercowetz.)

Six

HISTORIC CEMETERIES

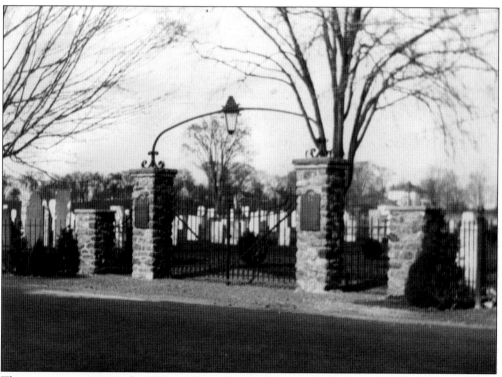

This gateway opens to the Wintonbury Cemetery, located on Tunxis Avenue just north of the center. Sometimes called the Old Bloomfield Cemetery, it was renamed the Wintonbury Cemetery in 1933. There are plaques on both sides of the gate. One reads as follows: "1736–1933, Old Wintonbury Cemetery. This gateway and fence were erected to the memory of the founders and descendants of ancient Wintonbury through the generosity of Mrs. Alice Bidwell Francis and Miss Caroline Roberts whose ancestors for four generations were buried here. All were direct descendants of John Bidwell, an original settler of Hartford." The other plaque states that care of this old burying ground is now vested in the Wintonbury Cemetery Association, incorporated on November 6, 1926.

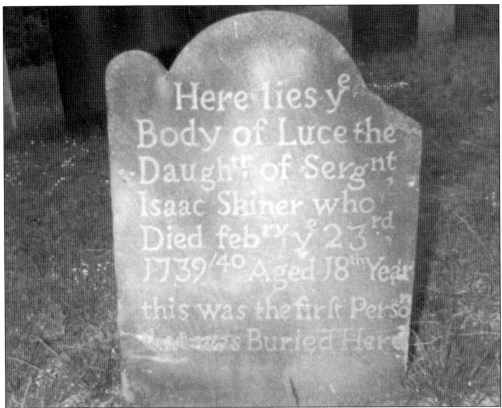

Luce Skinner, daughter of Isaac Skinner, was the first person buried in this cemetery.

Isaac Skinner, one of the early settlers, built this house on Park Avenue in 1770. He was a signer of both the petitions for "winter privileges" and "parish privileges."

The tomb of Reverend Hezekiah Bissell, the first minister of the Congregational church, is located in the Wintonbury Cemetery. The church was organized on February 14, 1738, and the next day Reverend Bissell came from Windsor to Wintonbury and stayed for 45 years. He built a home on Bloomfield Avenue in 1750.

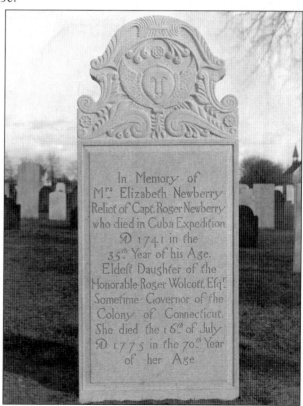

In the Wintonbury Cemetery, the restored Elizabeth Newberry stone mentions her famous husband and her parents.

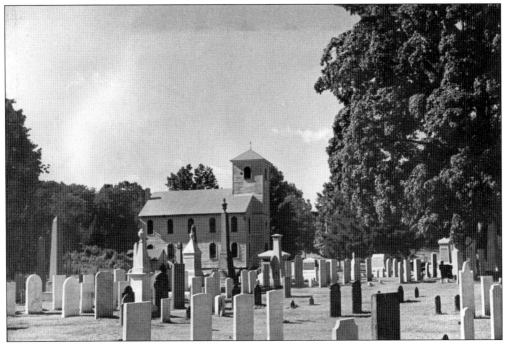

St. Andrew's Cemetery, located on the grounds of St. Andrew's Episcopal Church, on Tariffville Road, is another one of the early cemeteries. It is still in use.

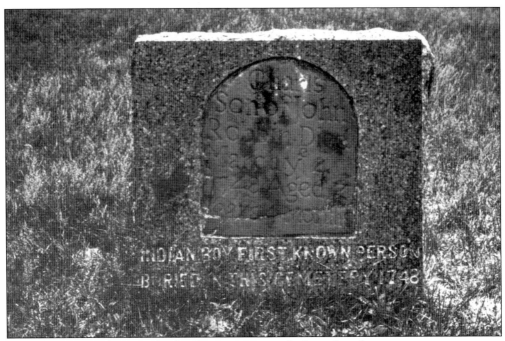

In 1748, an Indian boy was the first known person to be buried in the cemetery.

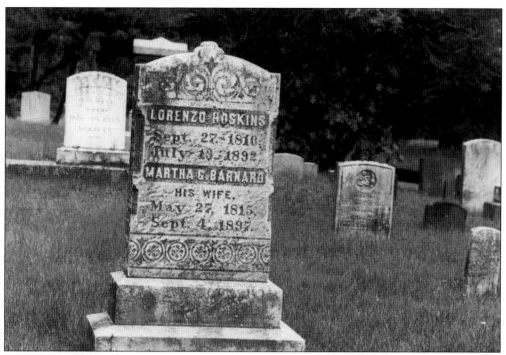

The Lorenzo Hoskins monument is one of the many stones with interesting markings.

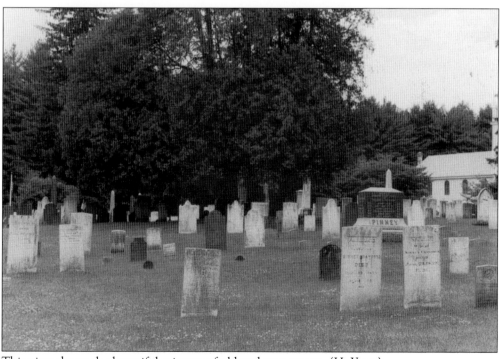

This view shows the beautiful mixture of old and new stones. (H. Yott.)

Nestled among the trees on a hill overlooking a neighborhood on Latimer Lane is a small burying ground that dates back to the Revolutionary War. It is now called Latimer Hill Cemetery, but it once was the backyard of an early settler, Capt. Hezekiah Latimer, who was granted land in Wintonbury in 1758 "under the King."

These stones mark the graves of the John T. Latimer family, the first family to be buried in this yard. The stone for John T. Latimer, grandson of Hezekiah, states that he was the first man to be buried here, on October 8, 1828. The stone of Latimer's daughter, Abigail, shows that she died in February 1828. It is believed that children were buried here between 1775 and 1828, but no markings can be found.

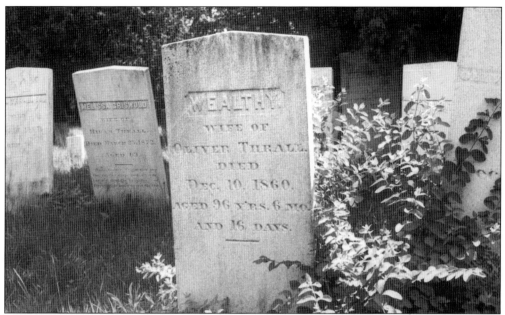

Wealthy Thrall was born in 1763, daughter of Capt. Hezekiah Latimer, the first Latimer to settle in Wintonbury. She married Oliver Thrall, who owned the Thrall Tavern. She lived to be 96 and never tired of telling stories about all her years living in Wintonbury. From her stories we learn how Latimer Hill became a burying ground. She stated that during the Revolutionary War, her father was away and her mother was ill when her little brother died. She made a little coffin, lined it with something soft, and buried him in the backyard.

This monument is a grim reminder of the perils of the Gold Rush. William Cooper and his wife were murdered in Utah in the Mountain Meadow Massacre.

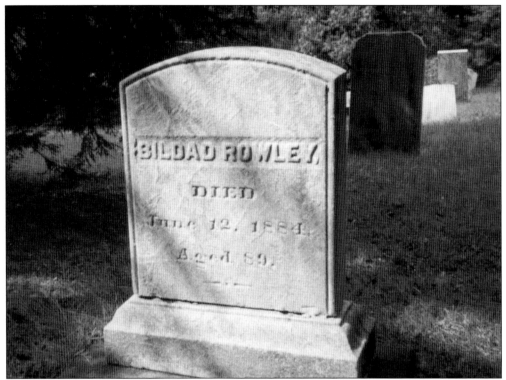

Capt. Bildad Rowley, born in 1795, served in the War of 1812. He lived a long life, outliving three wives, all buried alongside him.

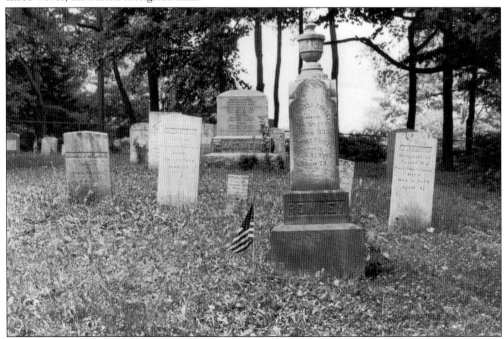

The Rowley monument has inscriptions on all four sides. Capt. Silas Rowley served in the Revolutionary War, from 1775 to 1783. (H. Yott.)

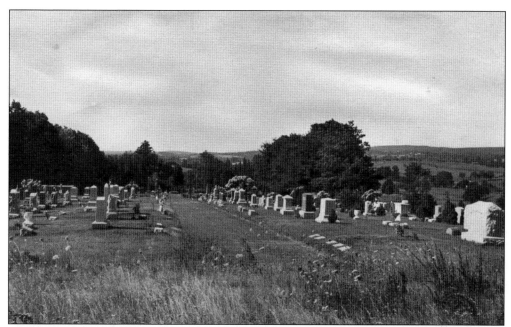

Property for this Mountain View Cemetery, located on Mountain Avenue, was purchased in installments. It was once called the West Cemetery. The plaque on the front entrance reads: "Organized May 1, 1854, Land acquired November 12, 1877. Cemetery developed, August 1879."

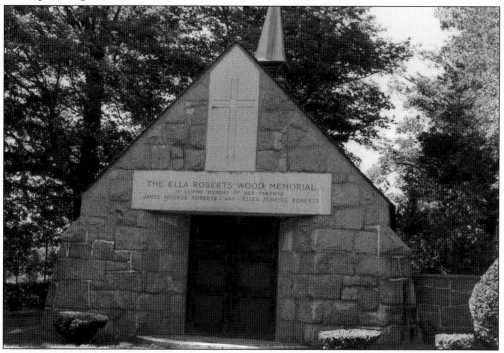

In 1927, Ella Roberts Wood left the cemetery money for a memorial vault and chapel. In 1937, the Ella Roberts Wood Memorial was erected. It was dedicated "In loving memory of her parents, James Monroe Roberts and Eliza Jenkins Roberts."

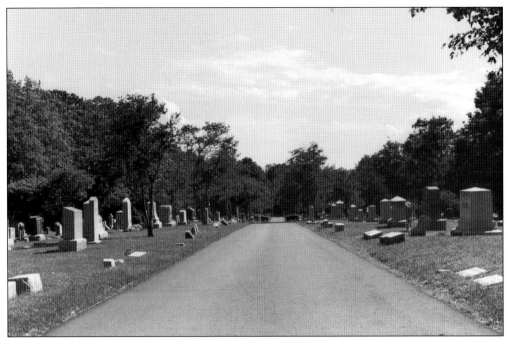

During the early 1930s, the important part of the Memorial Day observance was the decorating of the soldiers' graves in Mountain View Cemetery. Color guard, drum corps, veterans, and Scouts, followed by little children carrying flowers, marched through the gate and up this hill as the drums beat a slow funereal beat. Names were read out, and children ran to the graves to place their flowers.

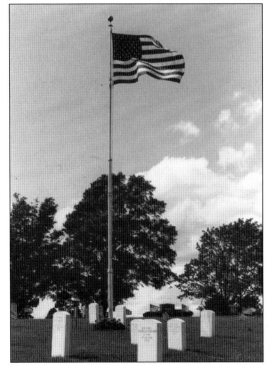

Soldiers Field was added to Mountain View Cemetery in 1948. (H. Yott.)

The Very Reverend James Hughes, pastor of St. Patrick's Church, Hartford, established Mount St. Benedict Cemetery on Blue Hills Avenue in 1874.

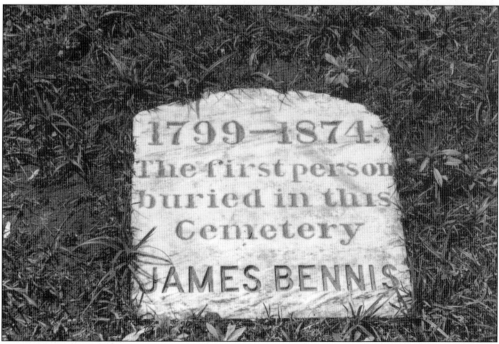

James Bennis was the first person buried in this cemetery. (H. Yott.)

This monument in the Mount St. Benedict Cemetery is dedicated to the Mission of Our Lady of LaSalette. The LaSalette Novitiate was located on Mountain Road in Bloomfield from 1913 to 1974.

The Mount St. Benedict Cemetery is a beautiful area filled with old and new monuments such as these, all kept in excellent repair.

"Here Lies an Infant Girl, Known and Loved of God Alone. April 1947" Bloomfield has a mystery infant buried in the Old Wintonbury Cemetery. Town workers found the body of a little baby and took it to police, who turned to Rev. Roscoe Metzger, pastor of the Congregational church, for guidance. Metzger gave her a burial service, and private contributions provided for this gravestone.

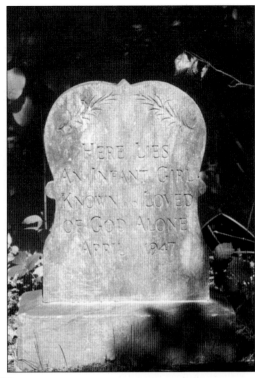

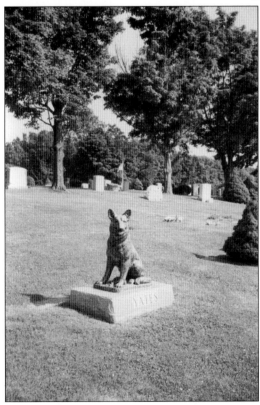

Man's (and woman's) best friend permanently stands watch over these graves in the Mountain View Cemetery.

Many people have chosen memorial benches for their loved ones, similar to this one in Mountain View Cemetery.

Something new was added recently to Mount St. Benedict Cemetery: the mausoleum.

Seven

COMMUNITY LIFE

According to tradition, Lemuel Haynes (1753–1833) spent two or three years studying for the ministry under Rev. Hezekiah Bissell, first minister of Wintonbury. Reverend Haynes served in the Revolutionary War and then became the first black minister of a Congregational church, in Torrington, Connecticut. He was also the first black person to receive an honorary college degree.

This little girl, Lucia Bidwell, grew up in Bloomfield, the daughter of a well-known Bloomfield family.

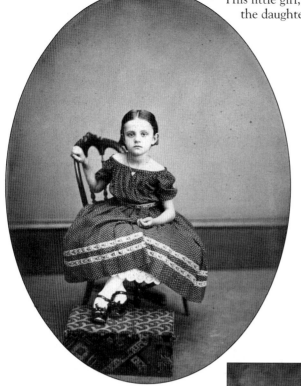

This shows Lucia Bidwell on her wedding day. She married Will Rowley, thus uniting two prominent Bloomfield families.

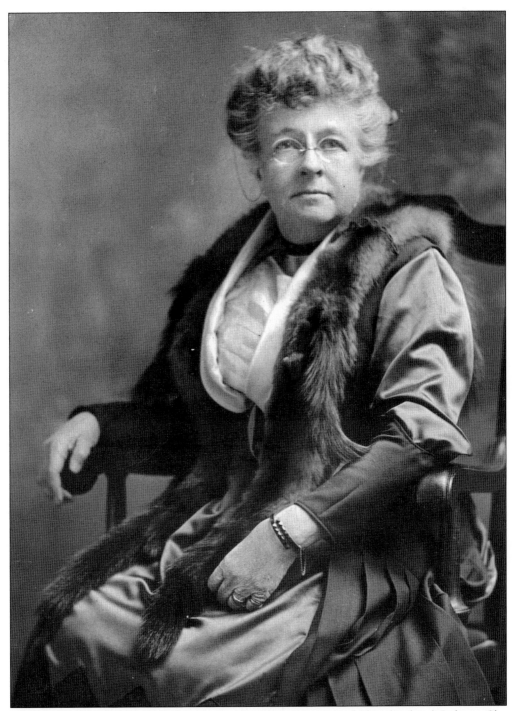

Ella Roberts Wood, born in 1852, was the daughter of James and Eliza (Jenkins) Roberts. She married Dr. George Wood, but he died three months after their marriage in 1878. She took an active interest in all town affairs, held many church offices, and served as a director of Prosser Library from its opening in 1903. Her obituary in 1927 read, in part, "In the passing away of Mrs. Ella Roberts Wood this church and community have suffered an irretrievable loss."

Jonathan Bidwell was the father of Jonathan, Frederick, and Dwight Bidwell. The Bidwell family operated a sawmill on Wash Brook in Bloomfield for many years.

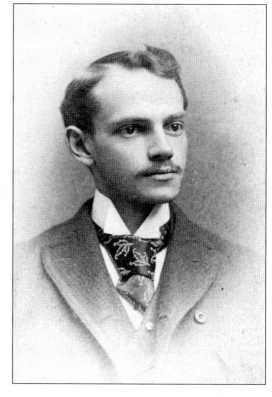

Frederick C. Bidwell graduated from Hartford High School in 1888. Attending high school was not too common in the 1880s, and he had to travel each day about eight miles from Bloomfield to Hartford. There was no public transportation in Bloomfield in those days. Bidwell became a successful businessman, founding and running Bidwell Hardware in Hartford for many years.

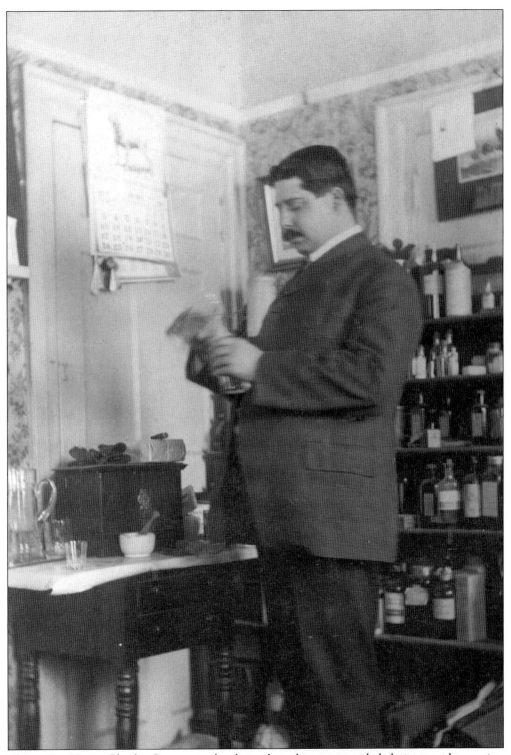

This is Dr. Henry Charles Spring, in the days when doctors provided their own pharmacies. Spring began his practice in Bloomfield in 1898, when he was about 20 years old.

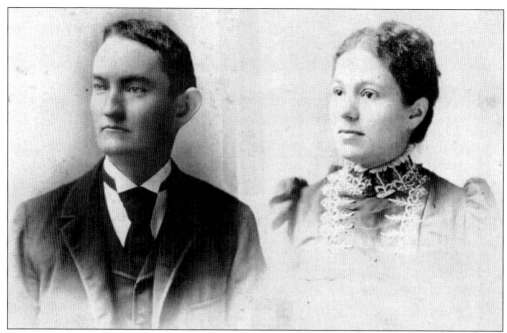

Helen Wilcox married George F. Woodford in 1890. She was a schoolteacher, as were several of her descendants. She was a member of the Daughters of the American Revolution and an active church worker. Her great-grandfather had made rifles for the Revolutionary War, at his farm, which was then located in Simsbury, later part of Bloomfield.

This is a later photograph of George F. Woodford. A prosperous Bloomfield farmer, he held town offices of health director, school treasurer, and school committee chairman. He was elected state representative and state senator from Bloomfield.

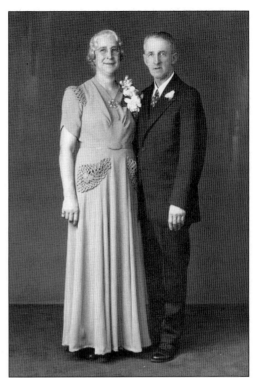

Treasured pictures of the Allyn family and relatives show Ernest E. Allyn and Florence (Mimer) Allyn celebrating their anniversary on March 24, 1942; Aunt Emma Beebe, as a child (lower left); and Grandma Griffin.

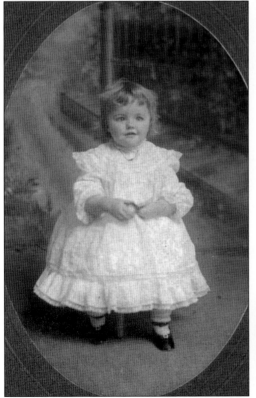

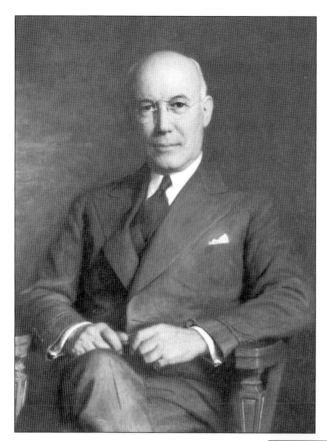

Philip B. Gale left a bequest to his church, and the addition that the church built was called the Gale Memorial in his honor. The Gale family had a beautiful home on one of Bloomfield's highest hills (see page 102). Every Easter for many years, a service was held at this estate and all watched as the sun rose in the east.

Nathan Flint Miller, born in Bloomfield c. 1850, was the husband of Nancy Ely and was a dedicated citizen of the town. He served as treasurer of the board of directors of the Prosser Library for 34 years, as a director of the Wintonbury Cemetery Association, and as a Sunday school superintendent for 23 years. In his spare time, he wrote an occasional column
for the *Hartford Times* about old houses in Bloomfield.

Surrounded by books is Jane Medbery, librarian of the Prosser Library for 10 years.

Every child who attended Bloomfield schools from c. 1922 to 1943 learned the Bloomfield school song, and every child learned Thanksgiving songs and several Christmas carols, new ones every year. Mabel Mann was the music teacher for the whole school system and conducted inspiring weekly lessons, annual concerts, and operettas.

Under W.T. Williams, town manager, the board of finance was redefined as the town council. This is a 1945 meeting in the old town hall, chaired by Dr. Eugene L. Bestor.

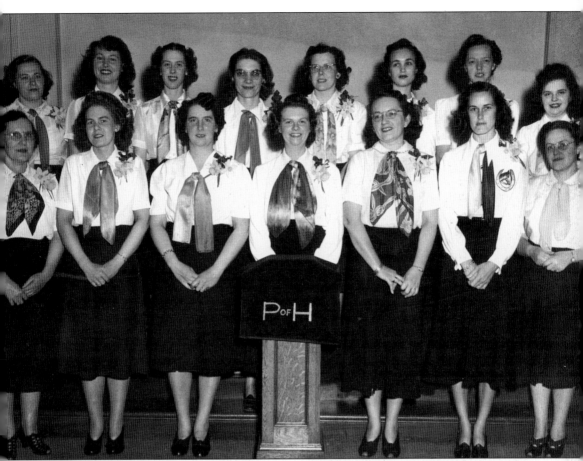

In 1875, two Grange organizations were founded in Bloomfield: Tunxis Grange, on March 24, and Bloomfield Grange, on March 25. They united in 1885 under the name Tunxis Grange. The Grange was unique in that women were accorded full membership from the very beginning. This picture shows a degree team, composed entirely of women. The women are, from left to right, as follows: (front row) Margaret LeHane, Joan Hocking, Muriel Case, Phyllis Hocking, Ann Chenette, Norma Heinaman, and Mildred Peck; (back row) Betty Long Hunter, Louise Szozda, Mary Wade, Laura DeLaura, Miriam Kelley, Mary Joyce, Mabel Beman, and Mary Walsh. (Joan Goetjen.)

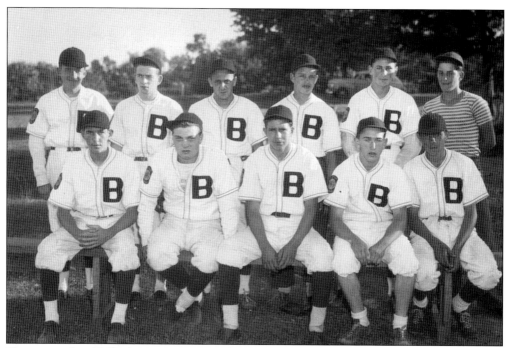

Shown is the 1945 American Legion baseball team. Members are, from left to right, as follows: (front row) Billy Clark, Fred Pro, Andy Backman, Allen Tull, and Ziggy Kriss; (back row) Corky Reid, Donald Reid, Frankie LaPenna, Billy Ventres, Chick Lagan, and Chris Webber.

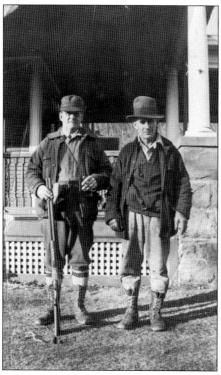

Charles Griffin (left) and Frank Barnard, hunting friends, pose for the camera at the end of a morning's adventure. Griffin and his brother, Frank Griffin, raised tobacco when they were not hunting. Frank Barnard ran a farm on Tunxis Avenue.

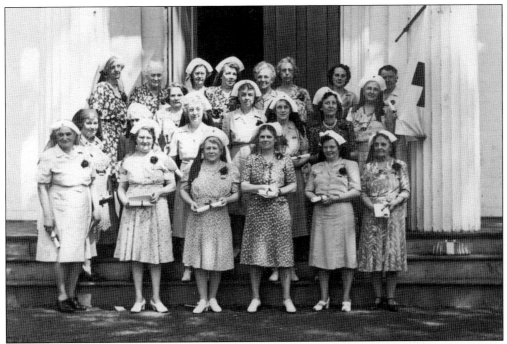

The Bloomfield Red Cross Auxiliary held a commencement exercise in June 1947. Shown are, from left to right, the following: (front row) Mmes. Meier, Fuss, Cooley, Utley, Guilmartin, and Etta Goodrich; (middle row) Mmes. Simmons, Hoover, Libbey, H.J. Watkins, L.T. Goodrich, L.B. Watkins, Washburn, and Bradley; (back row) Mmes. Wiley, William Wadhams, Lagan, Gabb, Bestor, Bidwell, Metzger, and Shaw.

Mae Manion grew up in Bloomfield, served as a school nurse during her career, and volunteered at the Senior Center when an occasion called for a nurse's help. (S. Whittaker.)

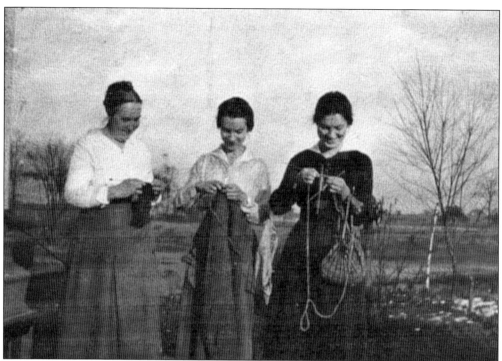

Sarah Eddy and her daughters Helen and Isabelle pose at the Eddy farm as they knit for the servicemen during World War I. (David Eddy.)

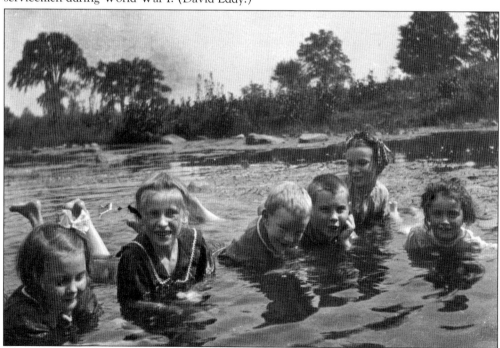

Wash Brook ran along the Eddy property. Here, cousins Isabelle Eddy, Theodore Eddy (third child shown), and their four Burnham cousins are bathing—or are they cooling off? (David Eddy.)

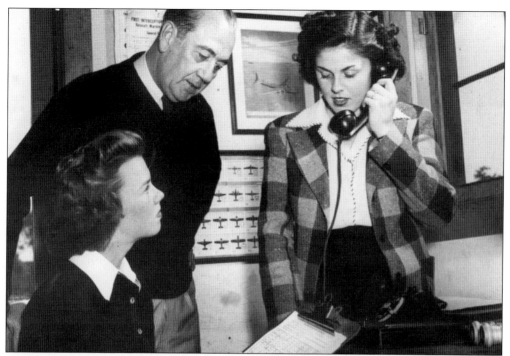

During World War II, Bloomfield operated an early warning station, with volunteer observers identifying and reporting all planes that flew overhead. Here are Gladys Tuttle, Jack O. Hoover, and Betty Lagan on duty.

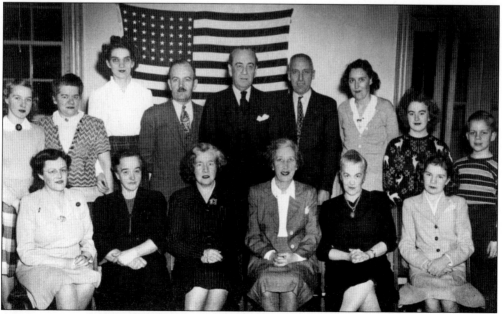

A newspaper called the *Messenger* was printed and sent to all service personnel and was also made available to the home folks. Pictures and news, both originating at home and relayed from those in the service, kept families and friends in touch with one another. This picture, taken in 1943, shows the volunteer staff of the newspaper.

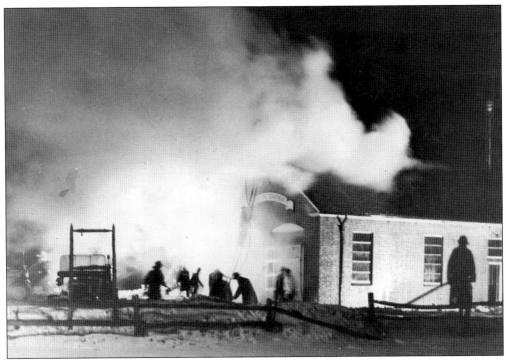

There are several volunteer fire departments in Bloomfield. Here is a group at weekly practice.

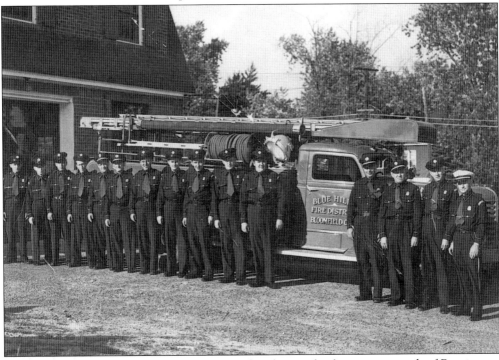

Blue Hills Fire Department Company No. 1 is lined up at the fire station, south of Bernies, on Blue Hills Avenue. This fire station was replaced by a larger one sometime after this photograph was taken.

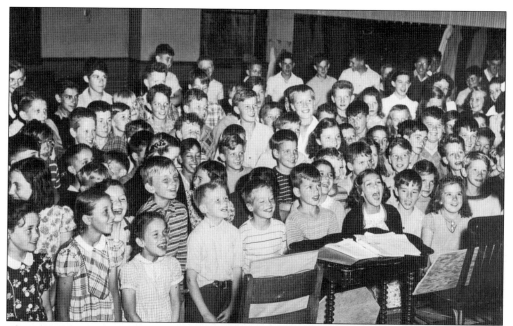

The Bloomfield Junior Fish and Game Club was organized c. 1947. Here are the young people gathering at a meeting of their new club.

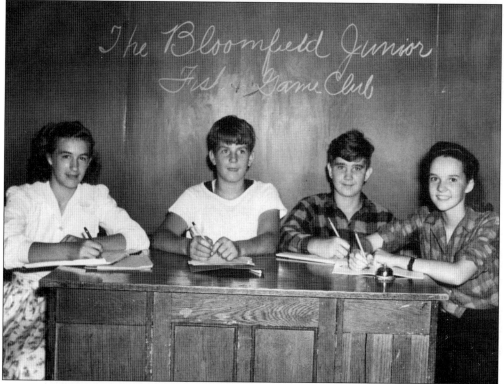

The Bloomfield Junior Fish and Game Club elects officers.

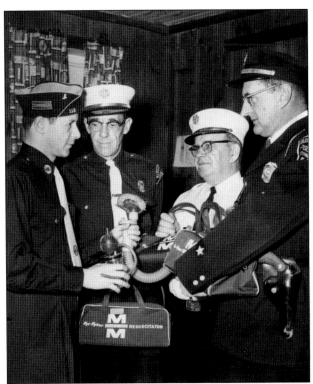

The commander of the American Legion presents new equipment to Adolph Jacobsen of the Bloomfield Fire Department, William Walsh of the Blue Hills Fire Department, and Herbert Beman, police chief.

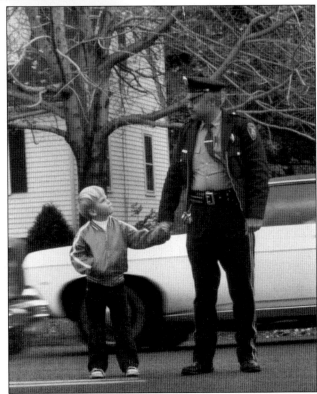

A young Bloomfield citizen gets a helping hand.

Eight

HOUSES OLD AND NOT SO OLD

In 1670, this was a little one-story house with an Indian door and an enormous central fireplace. The Indian door was later stored in the basement, and the roof was raised to add more bedrooms. Not many years ago, a car crashed through the funeral door right into the living room. The little house, at 4 Park Avenue, was built by the Goodwin family, owned by them for six generations and then owned by several generations of the Fuss family. After standing empty for several years, it was finally demolished in 2001.

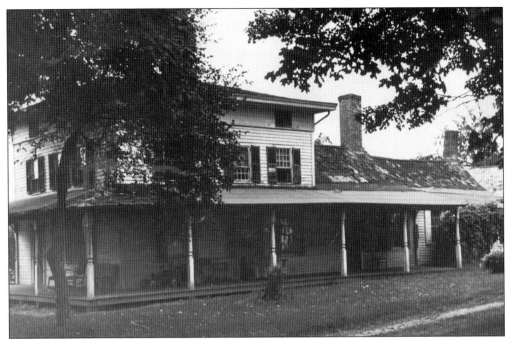

Edward Messenger, a citizen of Windsor, built this house in "the wilderness" in 1661, or perhaps 1642. Both dates can be found in the records. The house, added to many times, was torn down in 1946 to make way for post–World War II development on Blue Hills Avenue.

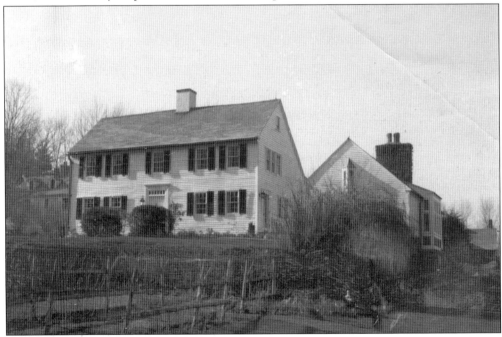

At the end of Mountain Avenue in Bloomfield, one can continue west to a house built in the first half of the 18th century. Stephen Goodwin married Sarah Gillett in 1727 and, by tradition, Goodwin's father built a house for the couple. For many years in the 20th century, Easter sunrise services were held on this hill, courtesy of the Gale family.

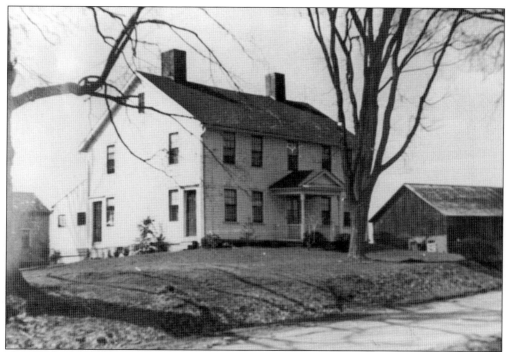

Filley Street was the main thoroughfare from the parish of Wintonbury to the home parish of Windsor. In addition to the Filleys, there were several Newberry families. Joseph Newberry built this house in 1785.

The barn is larger than the house. It also looks older than the house, but it was probably built by a much later generation than Joseph Newberry.

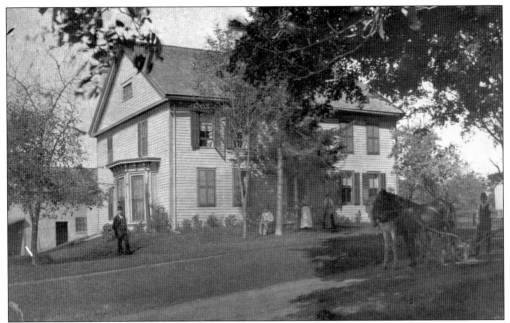

Itinerant photographers passed through town and took pictures of various houses, with the entire family assembled on the lawn. This was the Jonathan Bidwell house, on Bloomfield Avenue. The Bidwells lived in Bloomfield as early as 1776, and the family operated a sawmill on Wash Brook for more than 100 years. The house burned down in 1922.

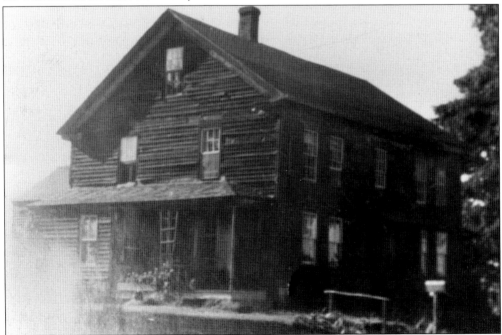

Capt. Edward Barnard lived here in 1755, and his descendants still live here (250 years later). Barnard's daughter, Hannah, remembered hanging over the gate to watch her father lead his troops down the road. The house, on Tunxis Avenue, is now painted white and looks much "younger" than it does in this picture.

These houses on Simsbury Road were built before Bloomfield was incorporated, when this area was still part of Farmington (the part of Wintonbury from which comes the "-ton"). Samuel Goodwin, who built this house in 1793, owned a carriage shop and made buggies and even a delivery wagon.

The house at 443 Simsbury Road was built by Madison Cadwell in 1774. His daughter Elizabeth taught at the Southwest District School. When the stone schoolhouse was being built, she held classes here in her family's parlor. Land on Simsbury Road belonged to the Cadwells from 1710 to 1924.

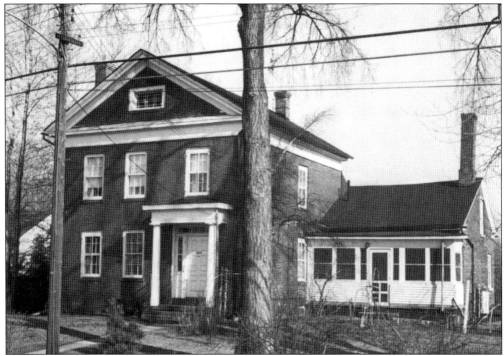

The many brick houses built in Wintonbury in the early 19th century deserve special recognition. The Eggleston family of Windsor brought a brick kiln to what is now Eggleston Street. The town then went through an "epidemic" of brick houses, many of which are still standing. Trumbull Hubbard was the owner of this house, on Cottage Grove Road, which was built in 1839, according to an inscription on a stone under the peak of the roof.

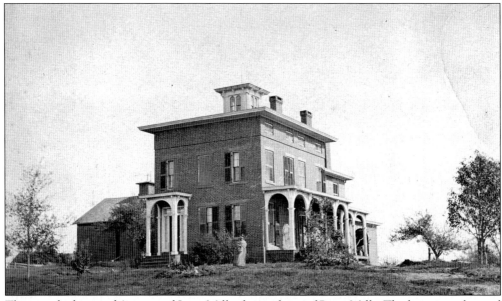

This was the home of Anson and Lucy Mills, descendants of Peter Mills. The house was located on a high hill on Wintonbury Avenue, adjacent to other Mills family homes. It was razed to make way for Seabury Retirement Community.

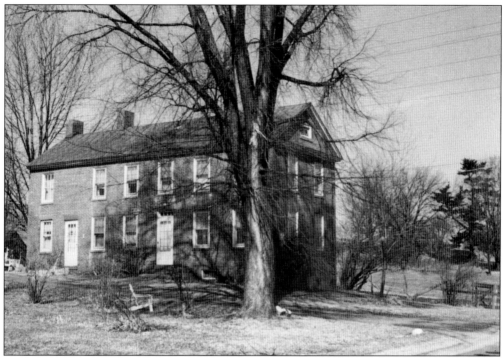

Brick houses do not last forever. This house, built on Filley Street in 1838 by George Rowley, was torn down in 1979.

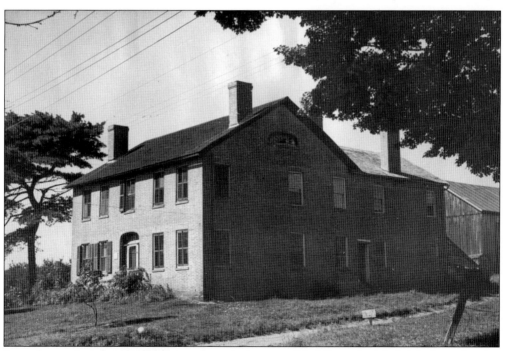

Records mention that the Egglestons brought in a portable kiln and made bricks from the clay found on this property. This house was built by Elijah Filley in 1800.

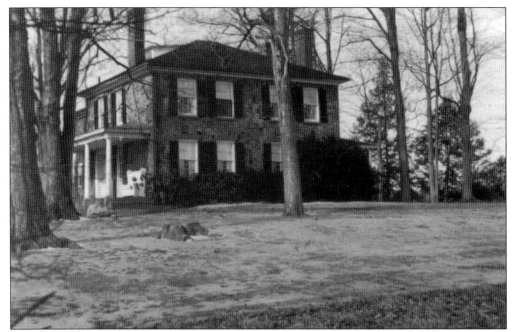

Several stone houses were erected in early Bloomfield, all built by illustrious citizens. Francis Gillette, who served in the General Assembly, built this beautiful home. Gillette was later a candidate for governor of Connecticut, running several times on the Liberty party ticket but never elected. He was an avid abolitionist.

It is difficult to interpret records regarding dates because the stone portion of these houses was added to existing buildings. This house, with a deer on the lawn, was built by Capt. David Grant for son David W. Grant and his bride. Captain Grant, a descendant of the original petitioners for Wintonbury Parish, served in the state legislature and was one of the founders of the Hartford Fire Insurance Company.

Several houses, almost identical, were built in the early 19th century. The first house was on the northeast corner of Park and Jerome Avenues. Built by Deacon Timothy Jerome, it was owned in the 1900s by Mel Barnard. It has since been torn down to make way for a shopping center.

The next house was built in 1840 by Amasa Jerome. Al Farrell, taxidermist, had his business here for many years. Senior citizen housing replaced it.

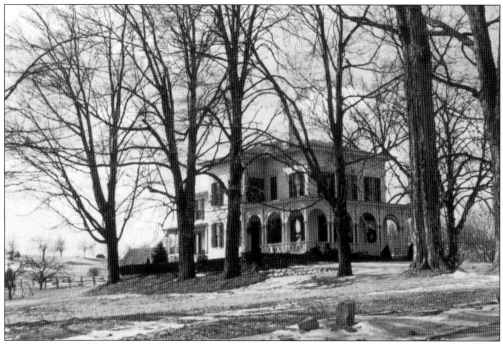

This house is still standing. It was built by Capt. David Grant at the end of Cottage Grove Road, but the road changed, so the address is now Maple Avenue. It was subsequently owned by R.G. Miller, Peter L. Brown, and the Connecticut General Company.

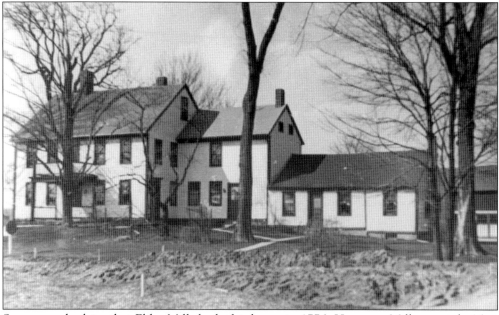

Some records claim that Elihu Mills built this house in 1776. However, Mills was only 16 at that time. He did live here; he was a descendant of one of Bloomfield's earliest settlers, an upright citizen, and a generous contributor to his church. The house is located on Mills Lane at Tunxis Avenue.

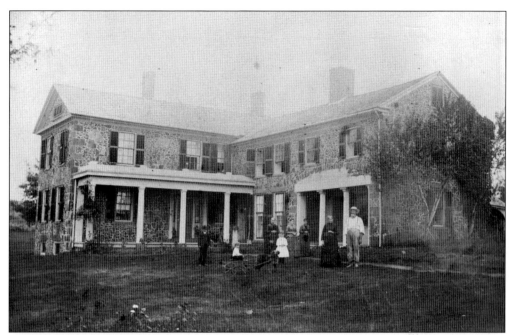

The Samuel Pinney family, shown in the picture, owned this property from 1854 to 1913, when it was sold to the LaSalette Missionaries. Samuel Pinney and his son Frederick Pinney were both prominent Bloomfield citizens. The house was built in 1834 by Capt. Oliver Filley for his son, Jay Filley. The town of Bloomfield now owns the property, and the Wintonbury Historical Society is in the process of restoring it.

Before 1897, electricity was extended from Hartford along Blue Hills Avenue over the city line to Bloomfield. Trolley cars soon followed, and city workers had an opportunity to move to the suburbs. Houses were built on the narrow, muddy roads near the city line, and the new residents took pride in their suburban homes. This is a group of homes on Hubbard Street.

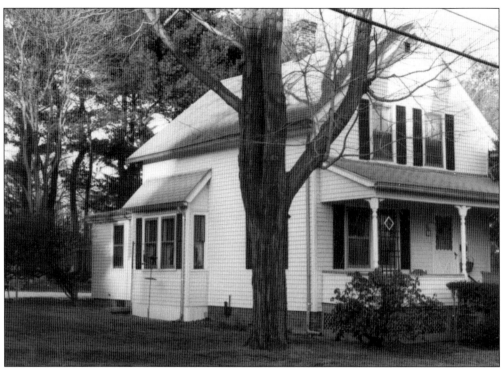

Elizabeth Avenue was on the trolley line. This home is where Mae Manion, school nurse for many years, grew up.

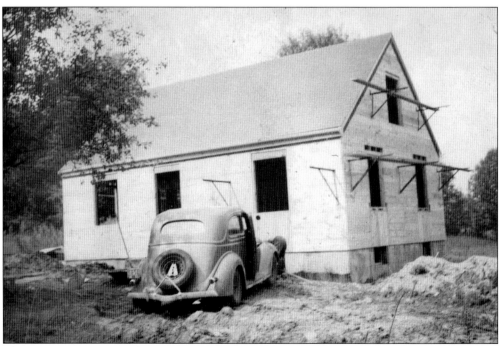

This is "one man's castle." In 1948, a World War II veteran had this house built for his new family.

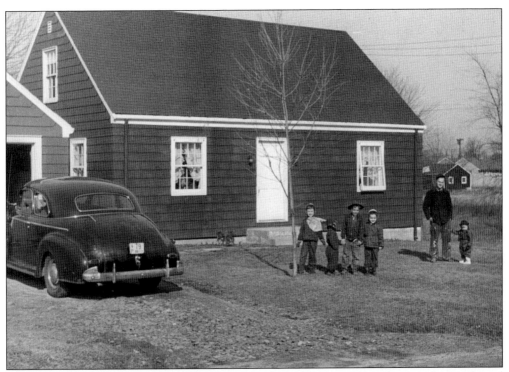

The house grew; the family grew. This is the same house 10 years later, showing the family and a young friend.

Many of the houses built for returning veterans continued to grow as the families grew. In the postwar years, families grew, the town grew, and the school system virtually exploded.

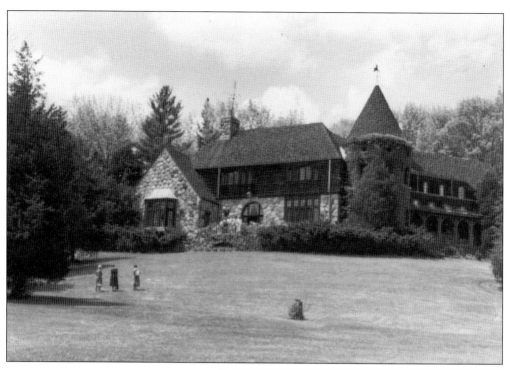

George A. Long invented the coin telephone. He and his wife were impressed by a chateau they visited in Normandy, France—so impressed that they built a replica of it in the hills of Bloomfield. Started in 1937, the house took about five years to complete.

Nine

AROUND
THE TOWN GREEN

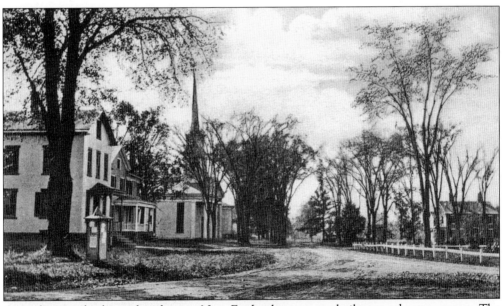

According to the best of traditions, New England towns are built around town greens. The green was the hub from which the town expanded. Here is Bloomfield's town green in the 19th century, the geographic and social center of the community. This picture was taken from the Congregational church, looking south down Bloomfield Avenue, with the Methodist church on the left and Lemuel Roberts's house on the right.

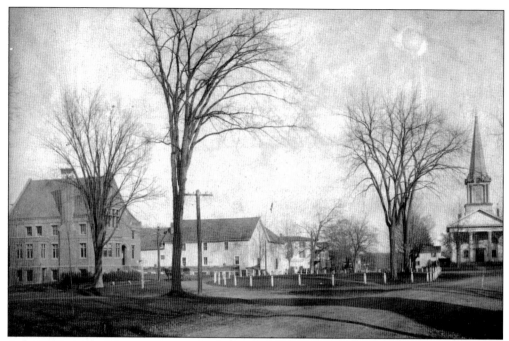

A *c.* 1907 view of the town green, looking north, shows the town hall on the left and the Congregational church on the right. Note that the electrical poles are in but there are no trolley tracks yet . The town green was big enough for a few of the contests at the Agricultural Society fairs.

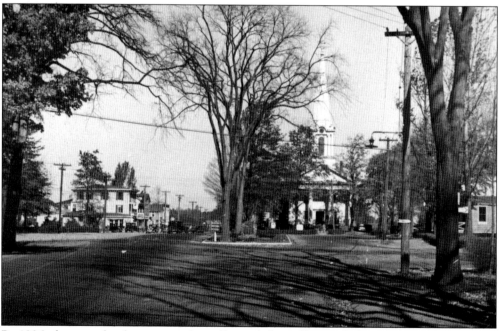

By 1936, the green has become much smaller and the trolley tracks have come and gone.

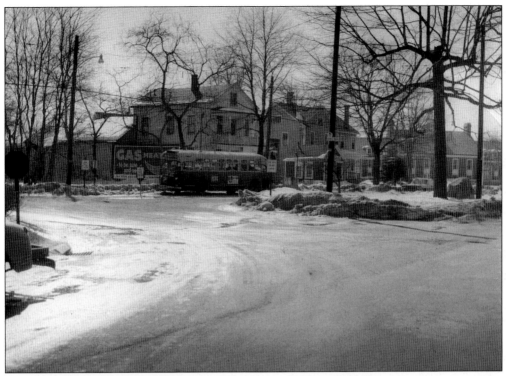

Can you spot the new town hall in this 1962 picture of Bloomfield Center?

A special event merits a parade. This was the parade and very special celebration for the 1935 tercentenary: 300 years a state, 200 years a parish, and 100 years an incorporated town—the greatest three-day celebration held in Bloomfield to date.

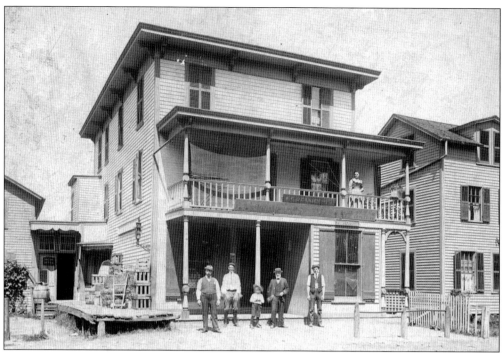

About the time of the Civil War, Sidney Colton started his country store, right at the green.

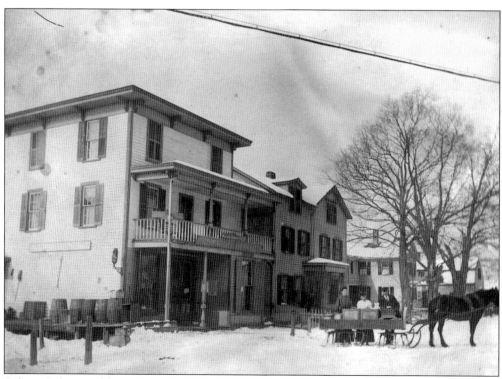

Sidney Colton and his son, Franklin Colton, also manufactured grain cradles. Records do not show what the Coltons sold, but the horse cart looks well loaded with goods.

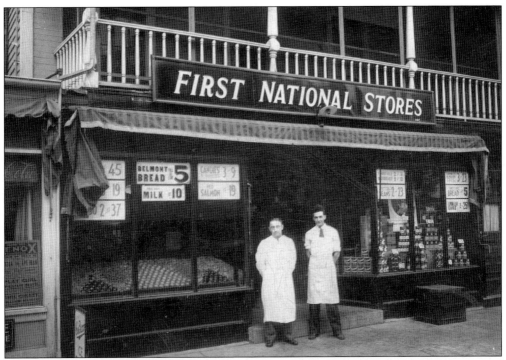

This is a view of the same building in 1933. Andrew Roth ran the First National Store, and Don Contafi worked with him.

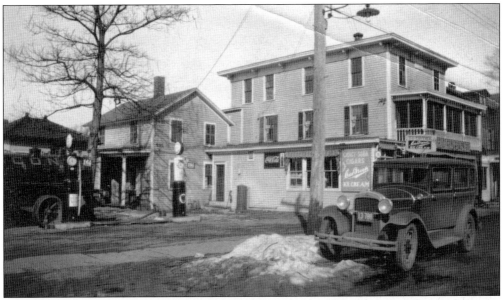

Tavener's grocery store was added on to the first building. This store had a counter where ice-cream sundaes were sold and a display of penny candy in the back, a favorite of the young children. During the Hurricane of 1938, Bill Tavener used a bicycle and a pulley to pump gas—1,000 gallons in one day. No other gas station could pump without electricity.

Historical events date this view to *c.* 1905. The town hall was built in 1902. The Gabb tobacco warehouse in the foreground burned down *c.* 1910. Mountain Avenue is visible beside the town hall—a neat, narrow road with a proper sidewalk. Today, it is a wide road with no sidewalk.

An informal Dance will be given in the New Town Hall, Bloomfield,

_____*190*

Come and bring your Friends, Gentlemen 50 Cents.

Committee, {
G. F. HUMPHREY,
L. H. BARNARD,
R. S. CAPEN,
E. E. CASE.
}

Here is an invitation to a very special event, a dance to celebrate the new town hall. Part of the building was completed in 1902, but the library did not open until 1903. Gentlemen, can you afford 50 cents?

Dr. Henry Gray served as the town physician for 20 years. He was a physician, a talented artist, and a concerned citizen who gave much time and effort in working to improve education in town. He lived in this house on Mountain Avenue, across from the library, facing a large green.

This view was taken looking west on Mountain Avenue. Dr. Henry Gray's house is on the left, the Bumstead house is down the hill, and in the distance is a house built in 1794 by Jonathan Palmer and later owned by Dr. Eugene Bestor and his wife. Mrs. Bestor was known for wearing elegant hats to church and always arriving just as the eleven o'clock bell tolled for the service. These families contributed much to Bloomfield.

This house, built in 1822 by Lemuel Roberts (one of several with that name), was located on the south side of this lawn. Lester A. Roberts later gave $100 for this lot to be added to the town green. Ella Roberts Wood, a prominent Bloomfield citizen, grew up in this house. More recently, it was owned for many years by Dr. Donald McCrann.

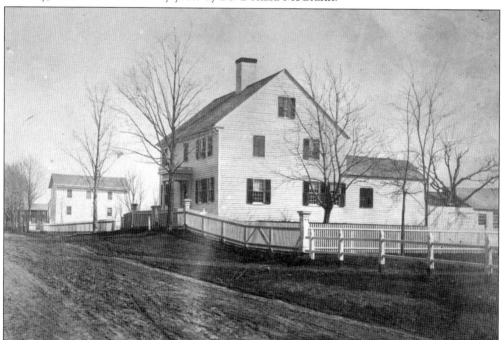

Park Avenue stretches east of the green. This house was built in 1794. It became the Baptist parsonage, and Rev. and Mrs. Harry Olcott lived here from 1918 to 1952, renting out a small apartment in the back. This site is now part of the town hall parking lot.

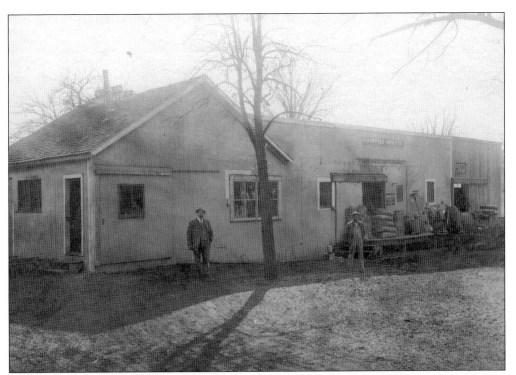

Wallace Dean's General Store was on Mountain Avenue, just behind Dr. Henry Gray's house. Later, Carpenter and Chapman opened a hardware store here and, after 1950, the building became a bicycle shop.

This site is now the location of Interfaith Homes, an independent but supervised housing complex for senior citizens.

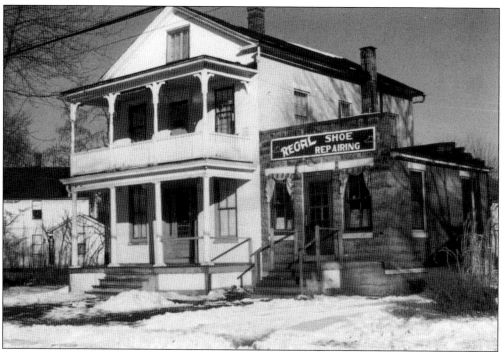

Old-timers can remember when Raymond Ladd had a grocery store in this building, on the town green, and Mrs. Ladd was the postmaster, with headquarters in a small portion of the store. The attached adjacent building served as ice-cream parlor and then as an expanded post office and later as a shoe repair shop.

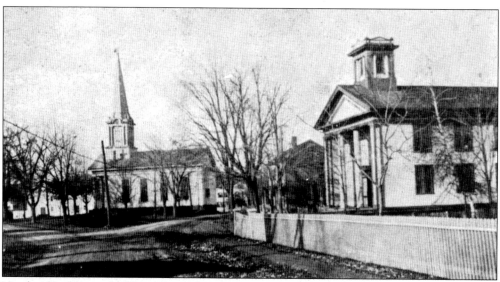

North of Ladd's store, Wintonbury Avenue turns eastward, away from the green. This 1908 picture of Wintonbury Avenue looks back toward the green. Notice the road behind the church. Few people can remember that street, and most who remember it do not know that it was called Church Street. It was closed many years ago to make way for an addition to the Congregational church. The picket fence in front of the Academy is long gone.

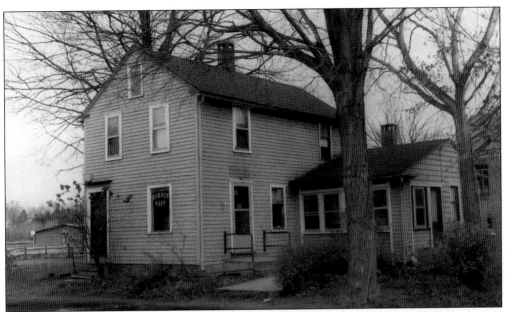

A shoemaker named Samuel Buckingham lived in this little house, on Tunxis Avenue, directly behind the church. Buckingham was the town's first librarian; he ran a circulating library out of his shop. For many years his picture was on the frontispiece of all Bloomfield library books. The building was taken down to make way for a parking lot, but not before it served as a barbershop for a number of years.

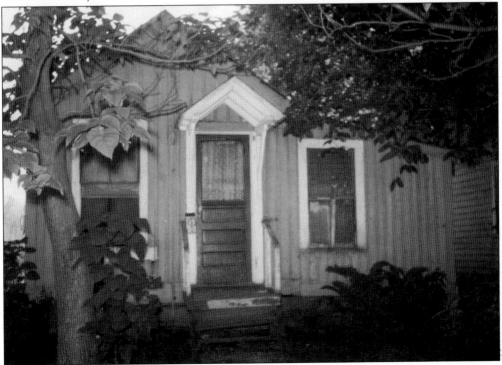

This little cottage, adjacent to Mr. Buckingham's shop, was the birthplace of James Batterson, founder of the Travelers Insurance Company.

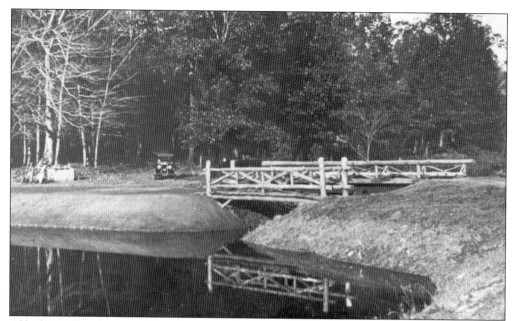

Alfred N. Filley gave seven acres of woodland to the Village Improvement Association in 1910. Later, other members of the Filley family added to the original gift. It took 20 years before Filley Park became a reality, a recreation area for the entire town to enjoy.

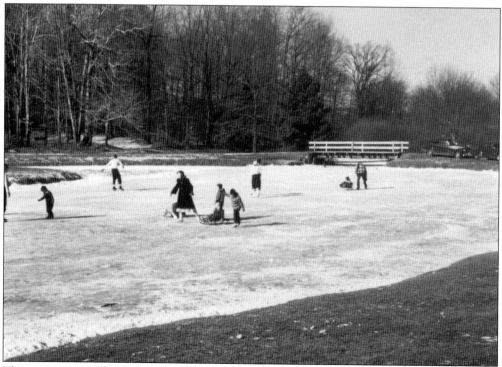

There was ice on Filley Park pond on New Year's Day of 1956. Enthusiastic Bloomfield residents celebrated the new year as they skated or sledded on the pond with their friends.

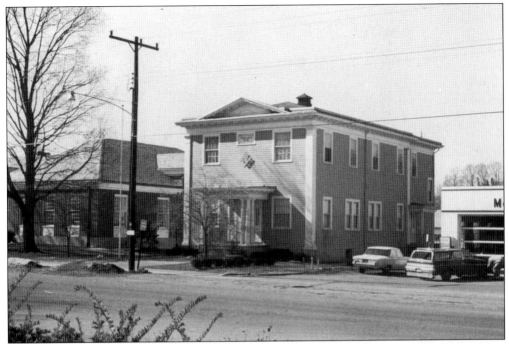

The Masonic Hall, located beside the Bloomfield Town Hall, was built in 1923–1924 with a great deal of volunteer labor. It has served as a hall not only for the Masons and the Order of the Eastern Star but also for dance classes, family Thanksgiving dinners, town meetings, and fifth-graders—who used it for two or three years as a classroom.

The town green was moved again and expanded. It is no longer an island.

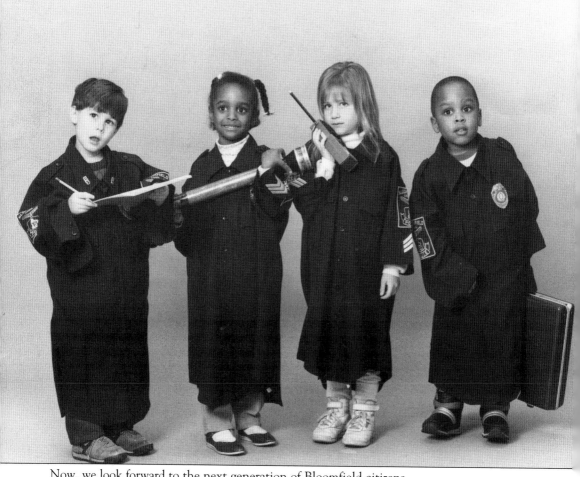

Now, we look forward to the next generation of Bloomfield citizens.